DRAW
COLOR & STICKER
ENCHANTED
SKETCHBOOK

Quarto is the authority on a wide range of topics.

Quarto educates, entertains and enriches the lives of
our readers—enthusiasts and lovers of hands-on living.

www.QuartoKnows.com

First published in the United States of America in 2016 by
Quarry Books, an imprint of
Quarto Publishing Group USA Inc.
100 Cummings Center
Suite 406-L
Beverly, Massachusetts 01915-6101
Telephone: (978) 282-9590
Fax: (978) 283-2742
QuartoKnows.com
Visit our blogs at QuartoKnows.com

10 9 8 7 6 5 4 3 2 1

ISBN: 978-1-63159-279-9

Cover Image: Suzy Ultman
Design and Page Layout: Megan Jones Design
Illustration: Suzy Ultman

Printed in China

DRAW
COLOR & STICKER
ENCHANTED
SKETCHBOOK

AN IMAGINATIVE ILLUSTRATION JOURNAL

✳ Suzy Ultman ✳

QUARRY

WELCOME!

HOW TO USE THIS BOOK

THE DESIGNS FEATURED IN THIS BOOK ARE SET UP IN PAIRS. THE FIRST TWO PAGES CONTAIN A FULL DRAWING, READY TO COLOR. COLOR WITH CRAYONS, COLORED PENCILS, COLORED MARKERS, OR EVEN WITH WATERCOLORS. IF YOU'RE FEELING ADVENTUROUS, DRAW IN A FEW EXTRA DETAILS WITH A PERMANENT MARKER, AND EMBELLISH WITH STICKERS BEFORE YOU COLOR. THE SECOND TWO PAGES IN THE PAIR CONTAIN A PARTIAL DRAWING WITH A SIMILAR DESIGN. YOUR TASK IS TO COMPLETE THE DRAWING. LOOK AT THE FINISHED DRAWINGS FROM THE PREVIOUS SPREAD FOR INSPIRATION, OR DOODLE FROM YOUR OWN IMAGINATION. A FINE-LINE, BLACK PERMANENT MARKER WILL COMPLEMENT AND BLEND IN WITH THE ORIGINAL DRAWING, BUT FEEL FREE TO DRAW USING ANY TOOLS AND COLORS THAT APPEAL TO YOU. EACH DESIGN THEME HAS A COORDINATED STICKER PAGE IN THE BACK OF THE BOOK. YOU CAN DRAW AND COLOR RIGHT ON TOP OF THE STICKERS TOO. THE LAST TWO STICKER PAGES ARE EXTRAS THAT CAN BE USED ANYWHERE. USE THE COORDINATED STICKERS, OR MIX AND MATCH THROUGHOUT THE BOOK TO CREATE UNIQUE DESIGNS IN YOUR OWN VISION.

FOLLOW THE PROMPTS AS YOU DRAW, COLOR, AND STICKER YOUR WAY THROUGH THIS BOOK. MOST IMPORTANTLY, HAVE FUN, AND TAKE CREATIVE CHANCES! THE RESULTS MAY SURPRISE YOU.

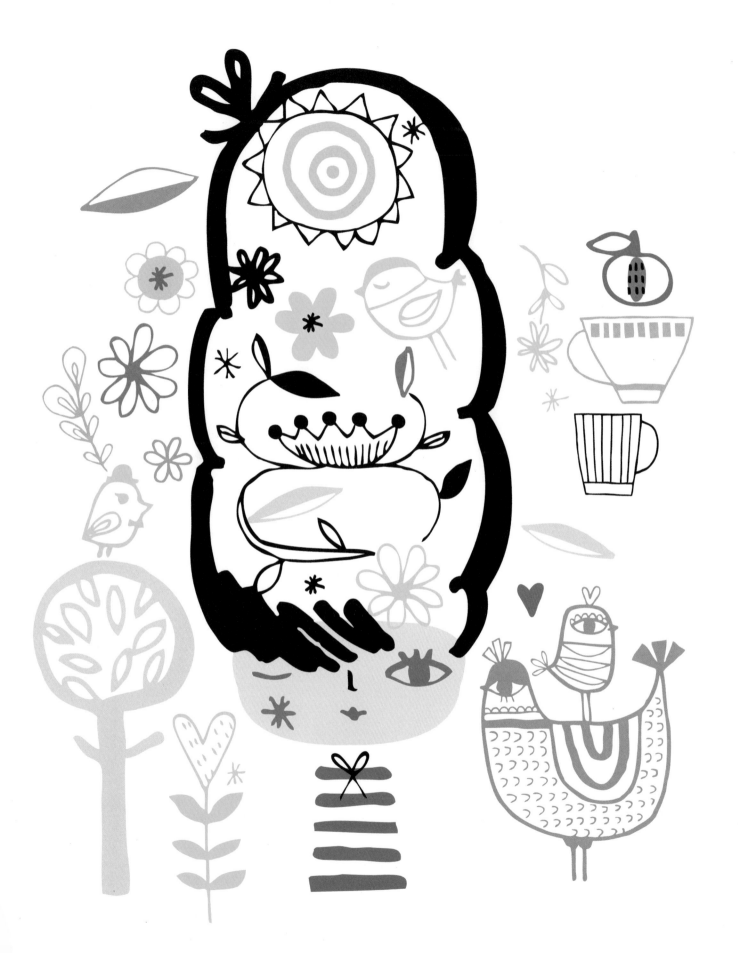

DRAW FACES, HAIRDOS, FLOWERS, AND BIRDS.
DECORATE THESE GALS WITH STICKERS.

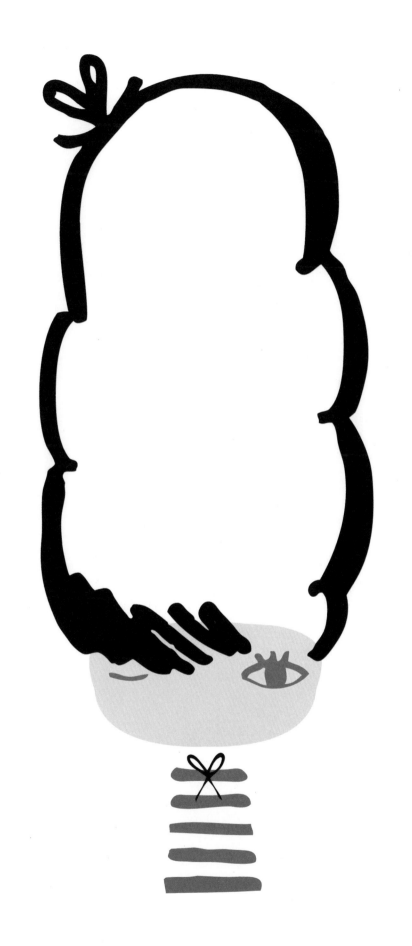

FINISH COLORING AND ADD DETAIL TO THIS ARTSY TOWN.

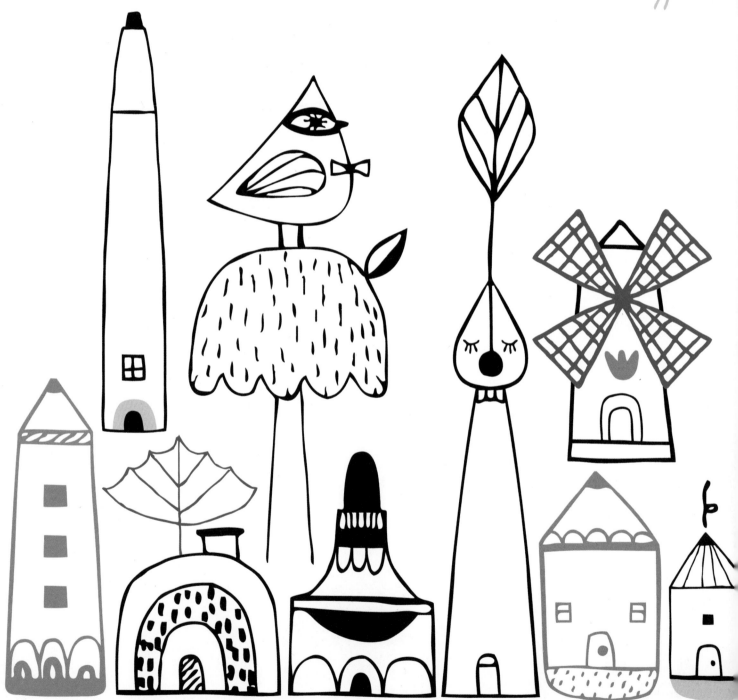

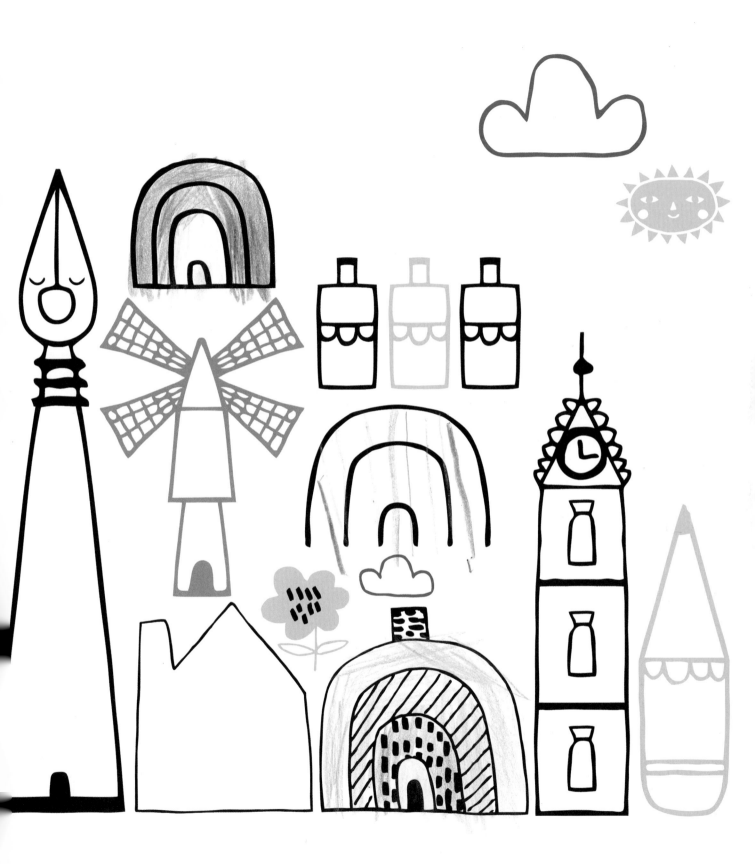

ADD WINDOWS AND DOORS! THEN, DRAW MORE
BUILDINGS, FLOWERS, CLOUDS, AND RAINBOWS.
DECORATE THE TOWN WITH STICKERS.

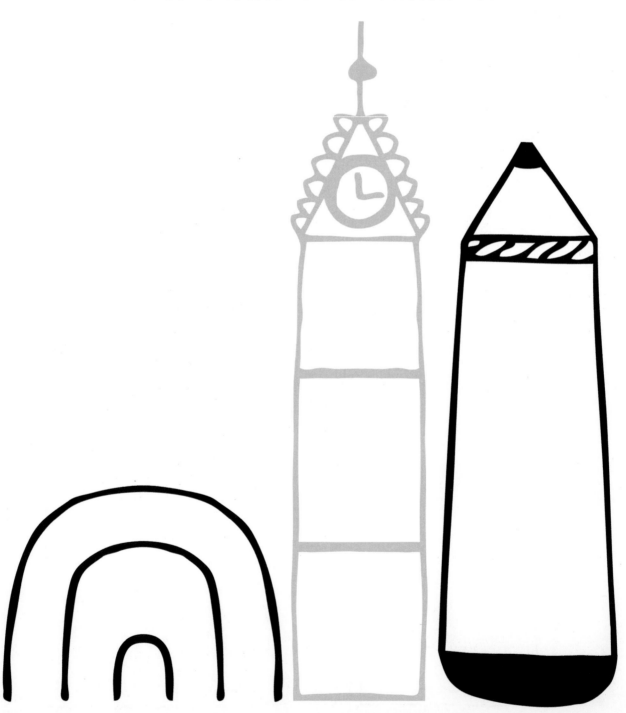

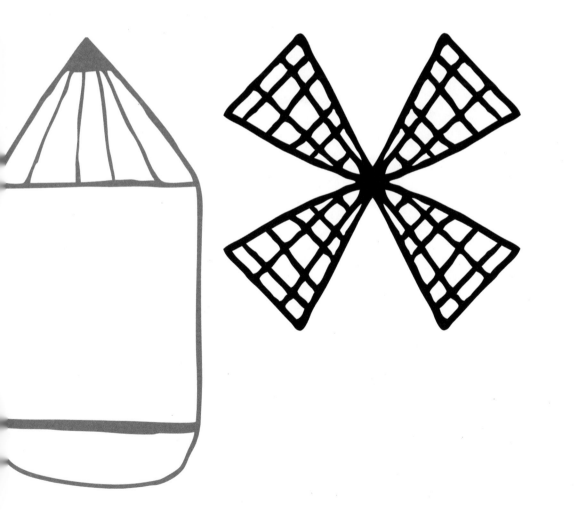

FINISH COLORING AND ADD DETAIL TO THIS PACHYDERM PARTY.

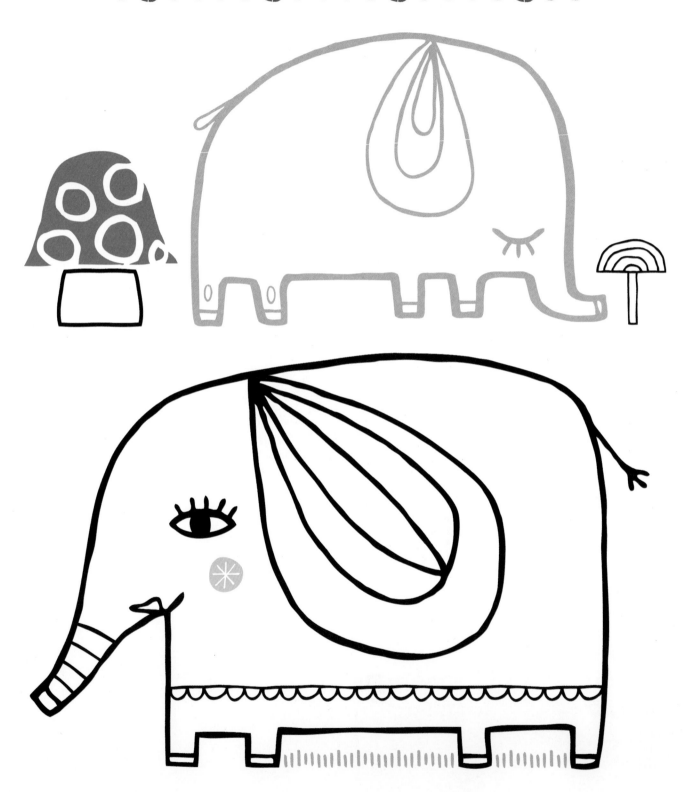

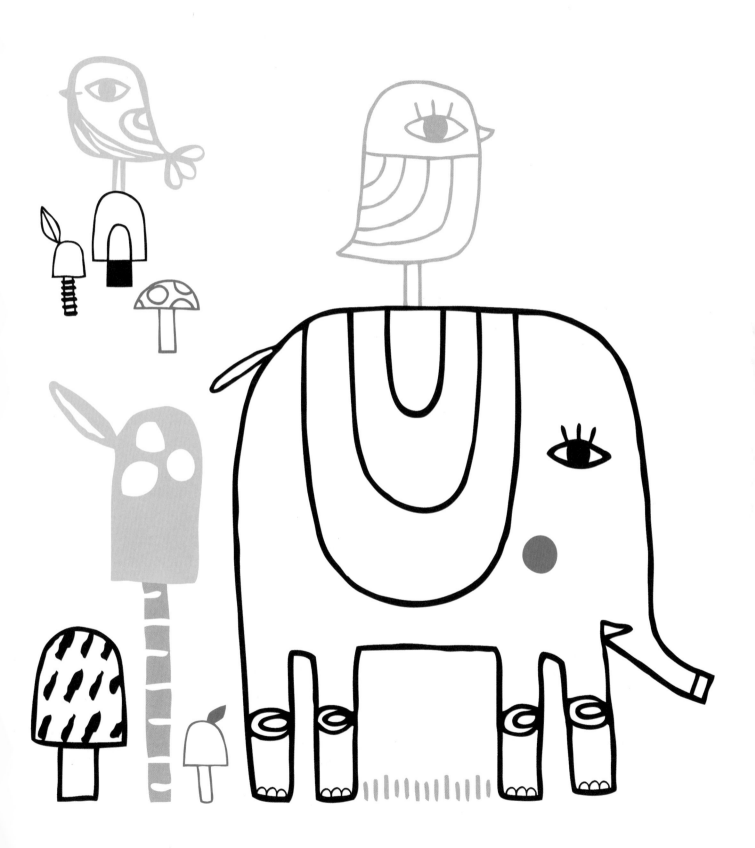

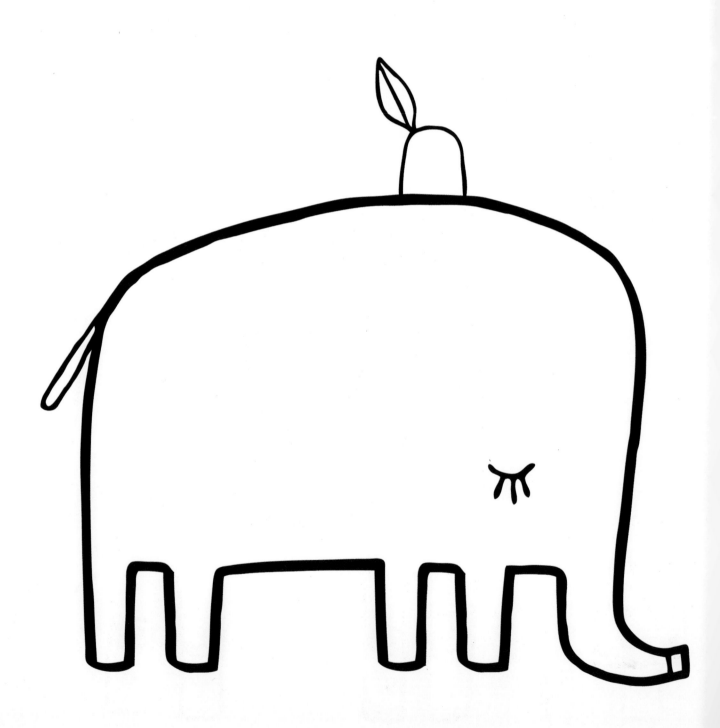

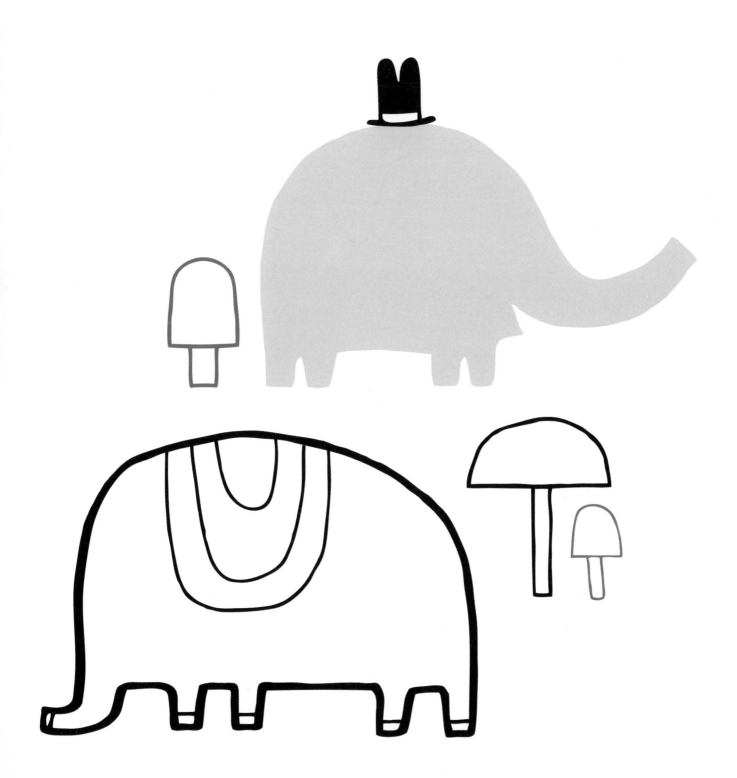

FINISH COLORING AND ADD DETAIL TO THIS FOXY BUNCH.

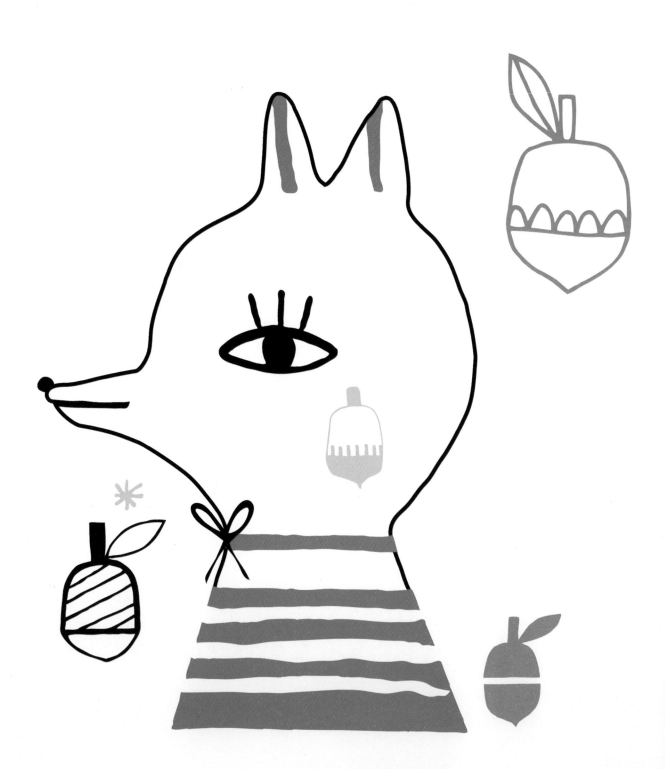

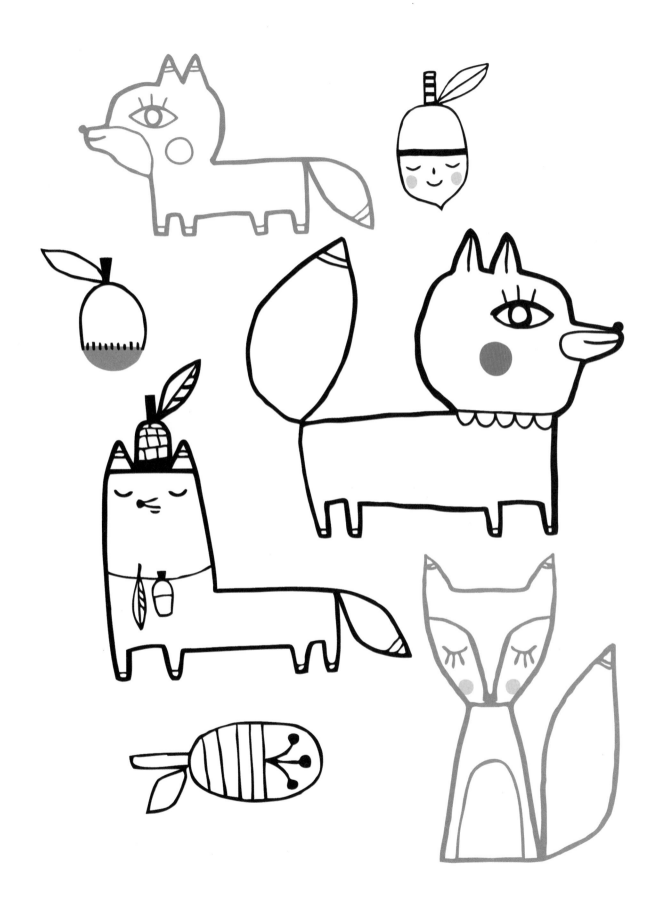

DRAW FACES, MORE FOXES, AND ACORNS.
DECORATE THE FOX DEN WITH STICKERS.

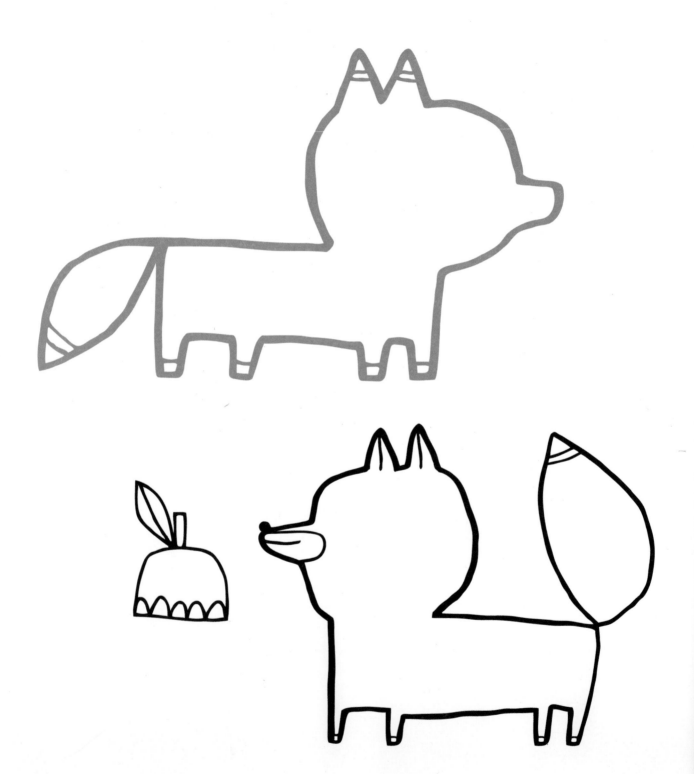

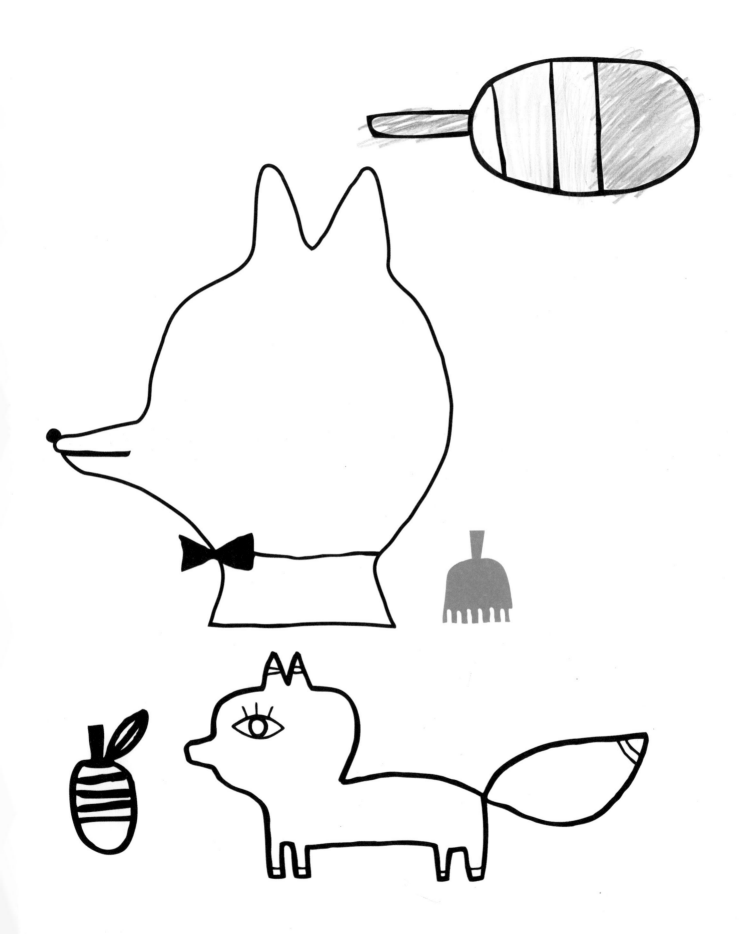

FINISH COLORING THIS PRETTY PATTERN.

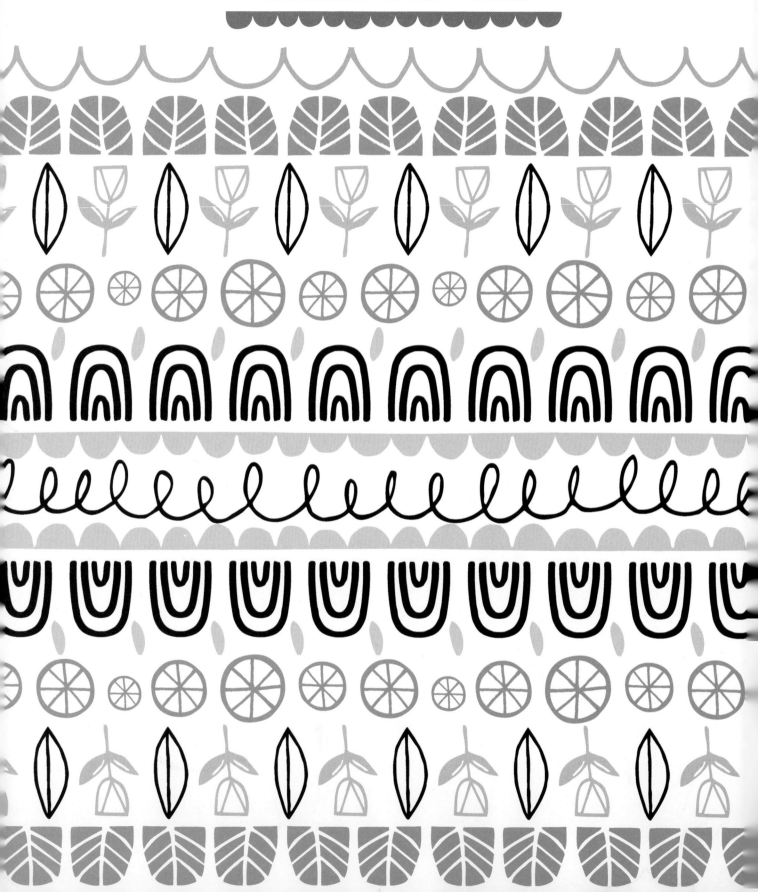

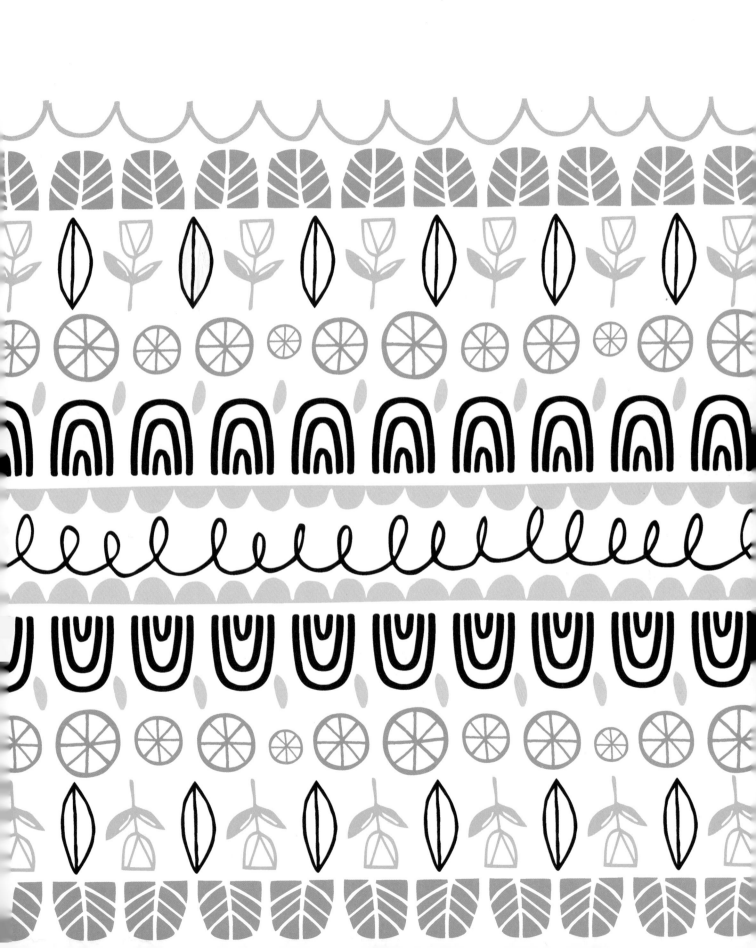

DRAW AND DECORATE THE PATTERN WITH STICKERS.

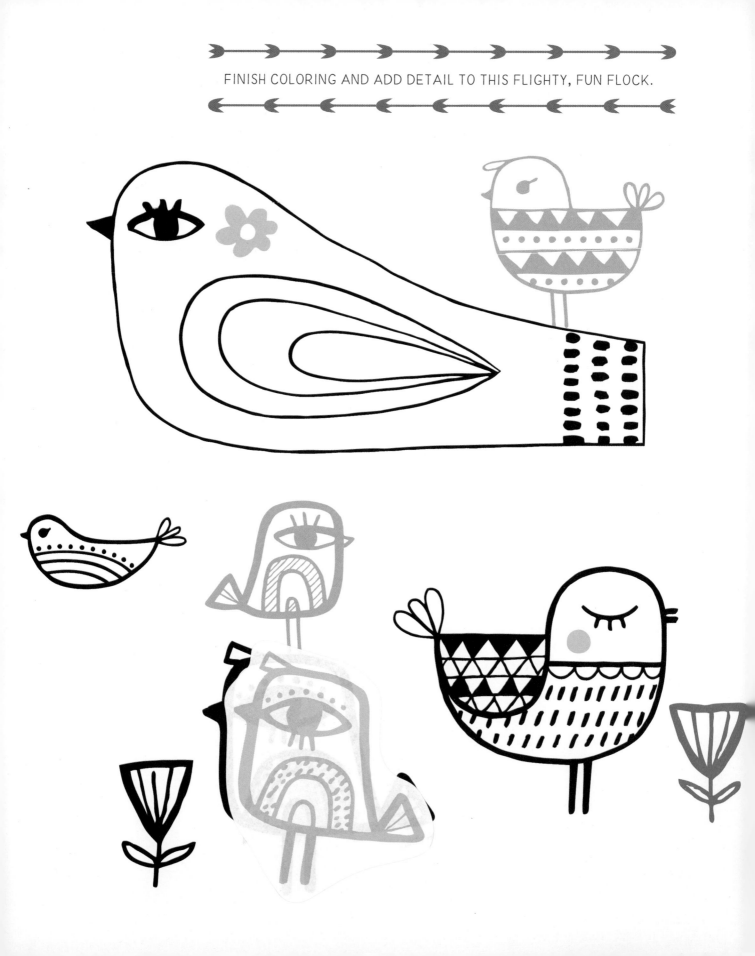

FINISH COLORING AND ADD DETAIL TO THIS FLIGHTY, FUN FLOCK.

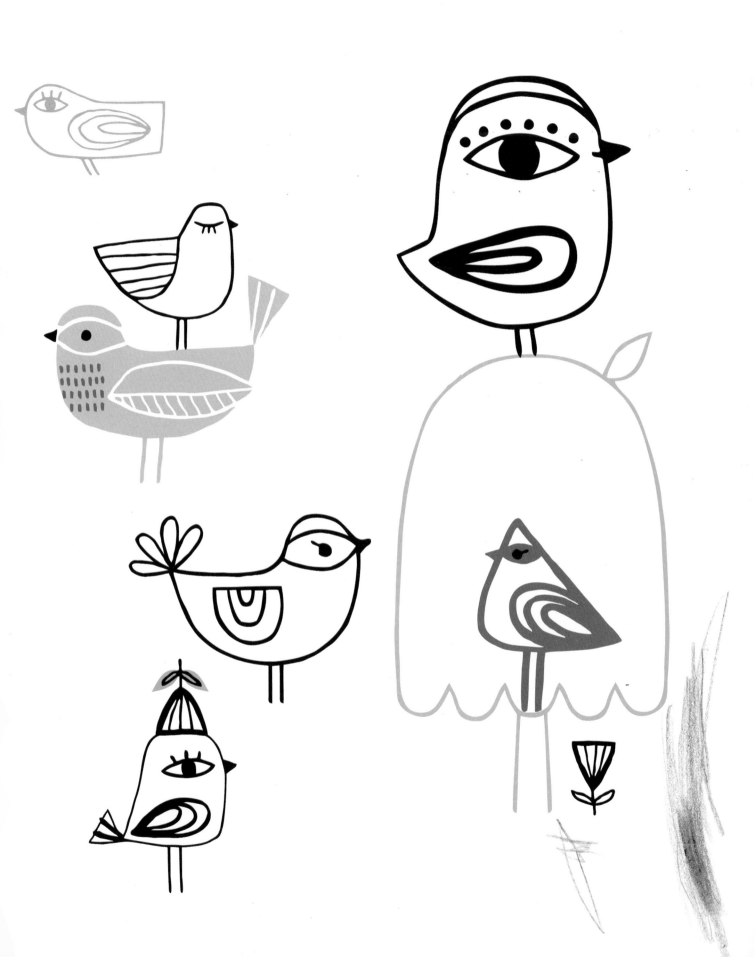

ADD EYES, WINGS, AND MORE BIRDS.
DECORATE THE PAGES WITH STICKERS.

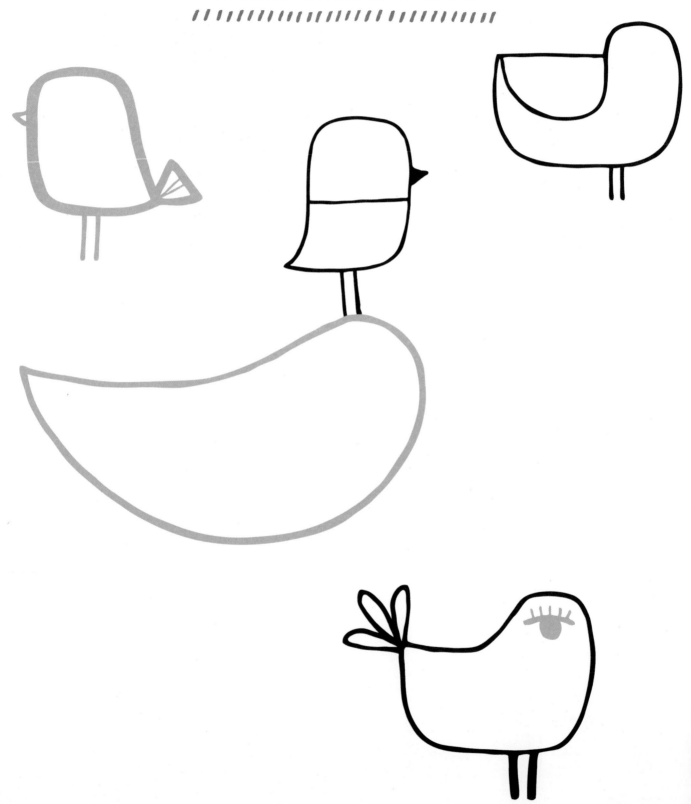

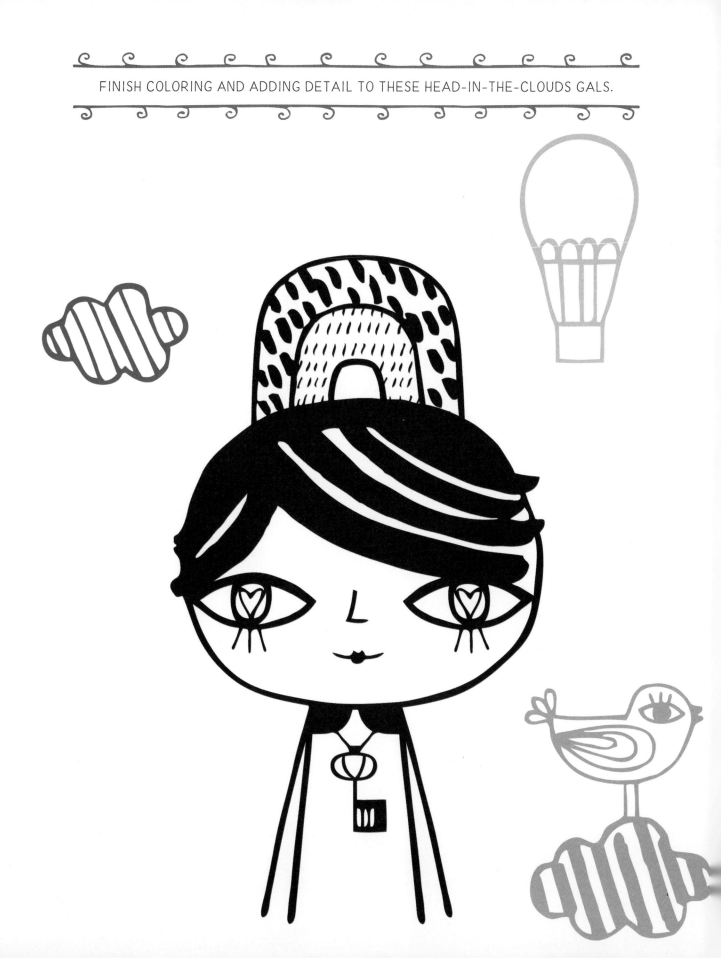

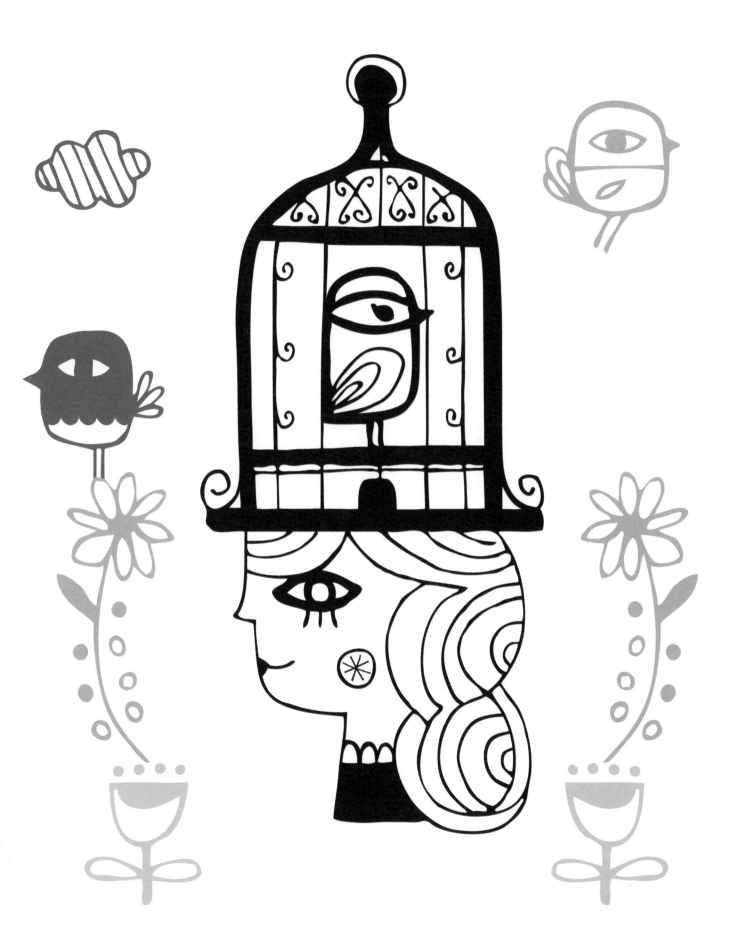

DRAW THE FACES AND HAIRSTYLES FOR THESE LOVELY LADIES.
ADD STYLISH TOUCHES WITH STICKERS.

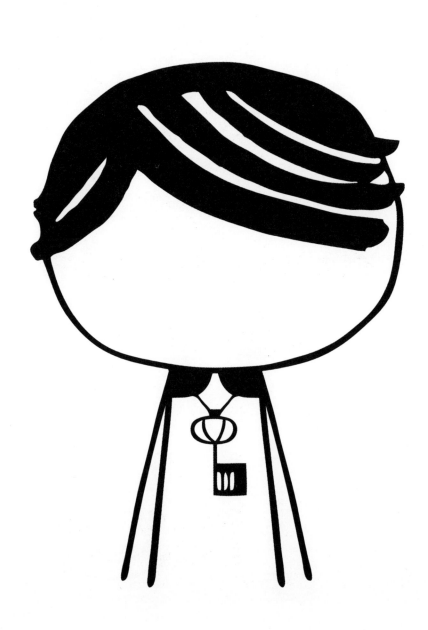

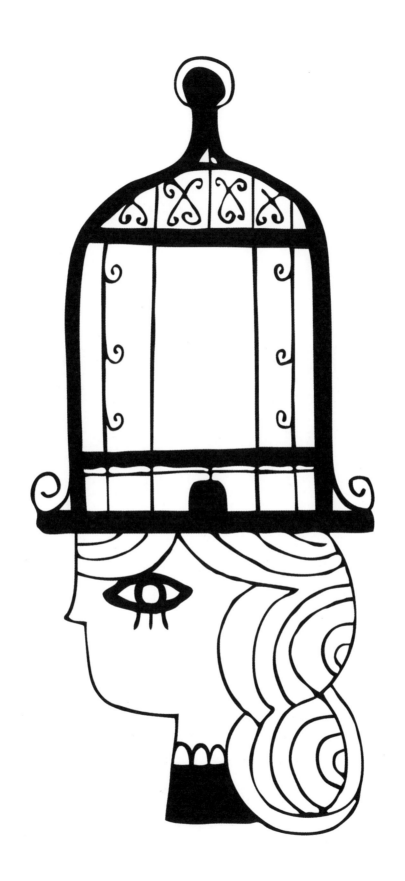

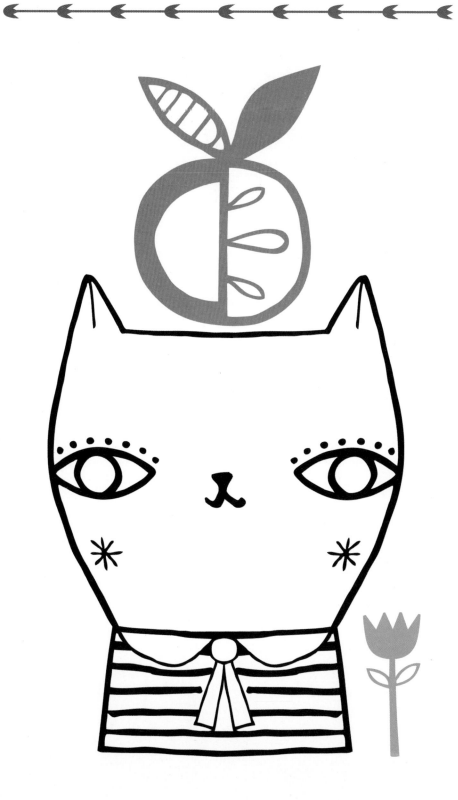

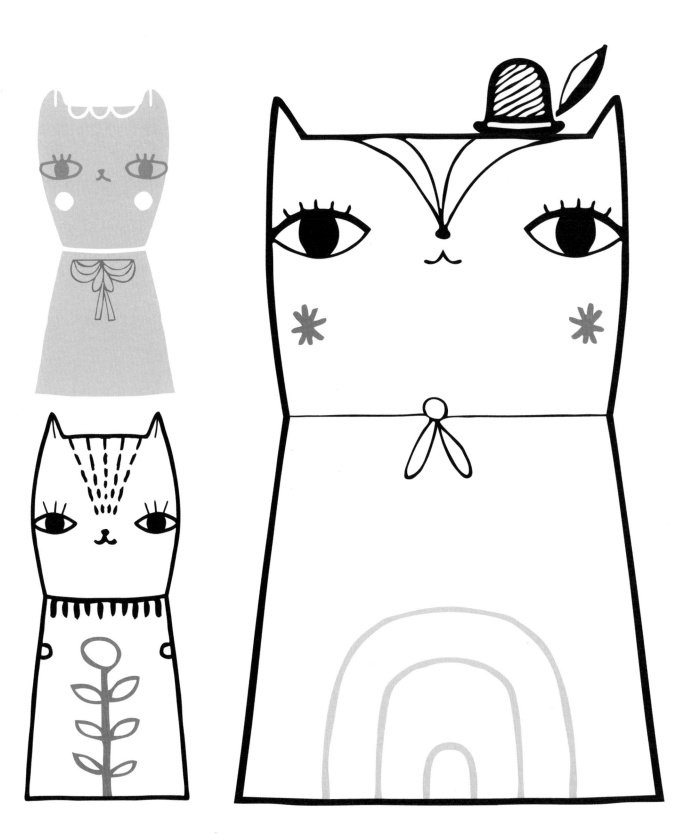

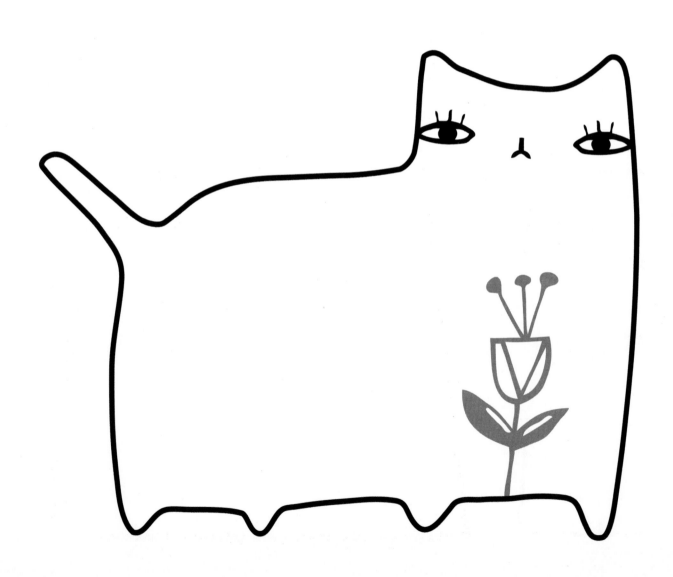

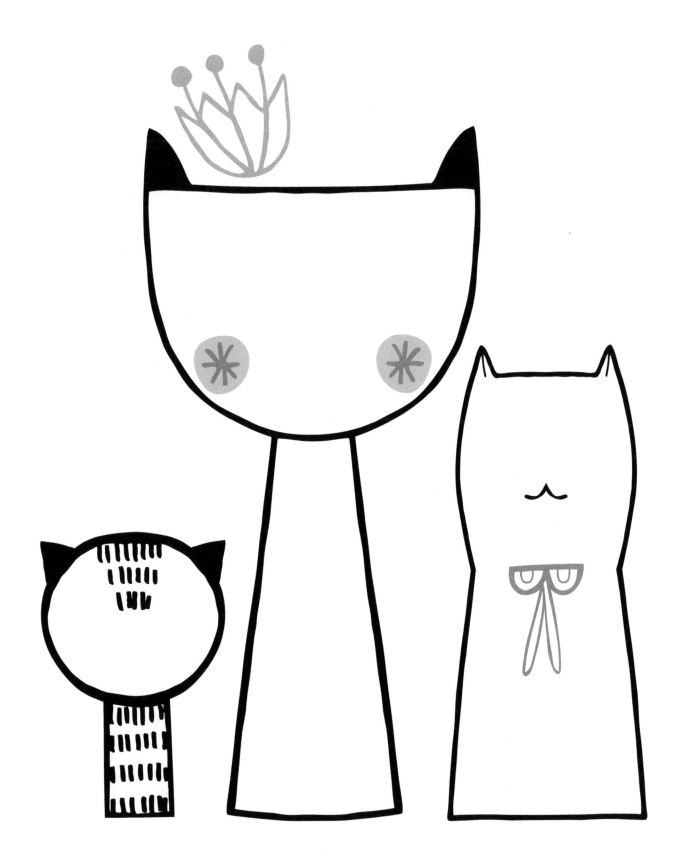

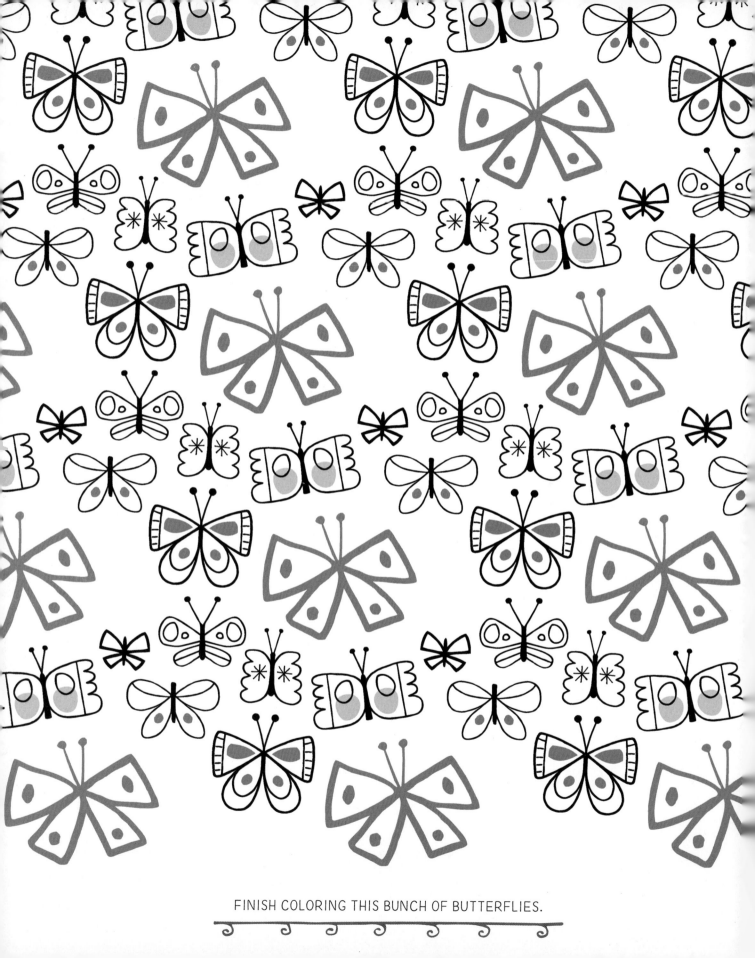

FINISH COLORING THIS BUNCH OF BUTTERFLIES.

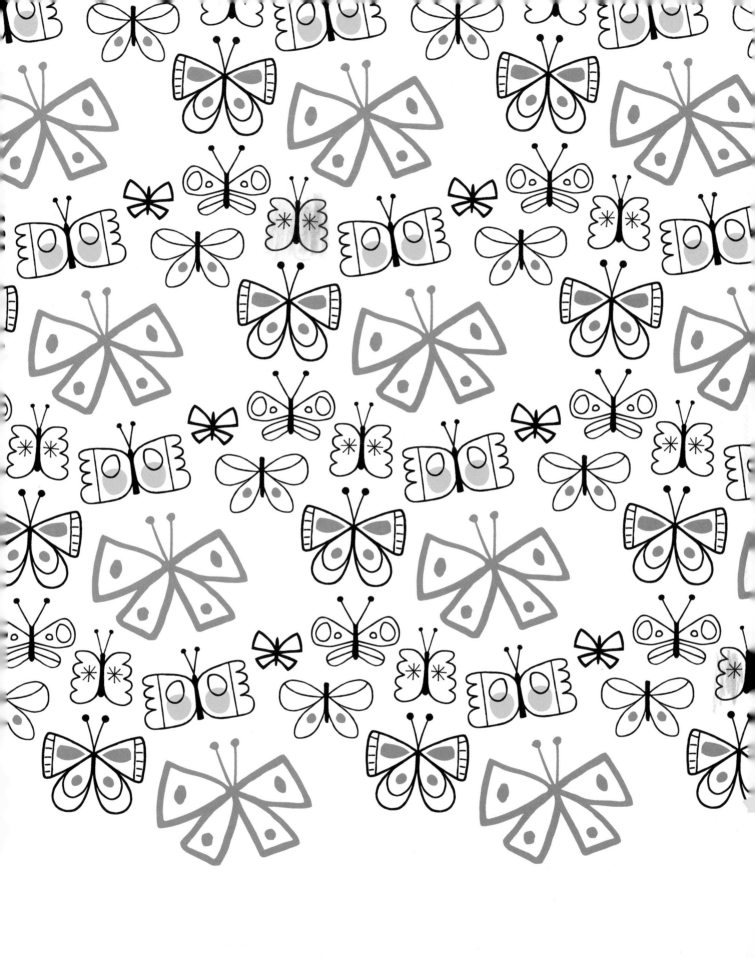

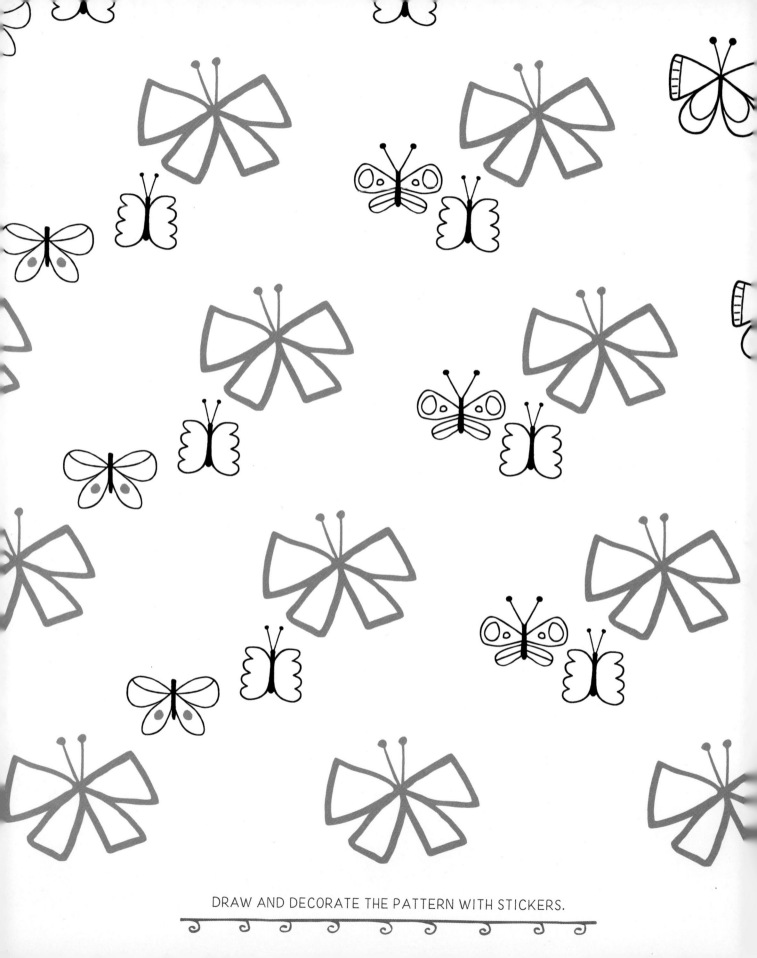

DRAW AND DECORATE THE PATTERN WITH STICKERS.

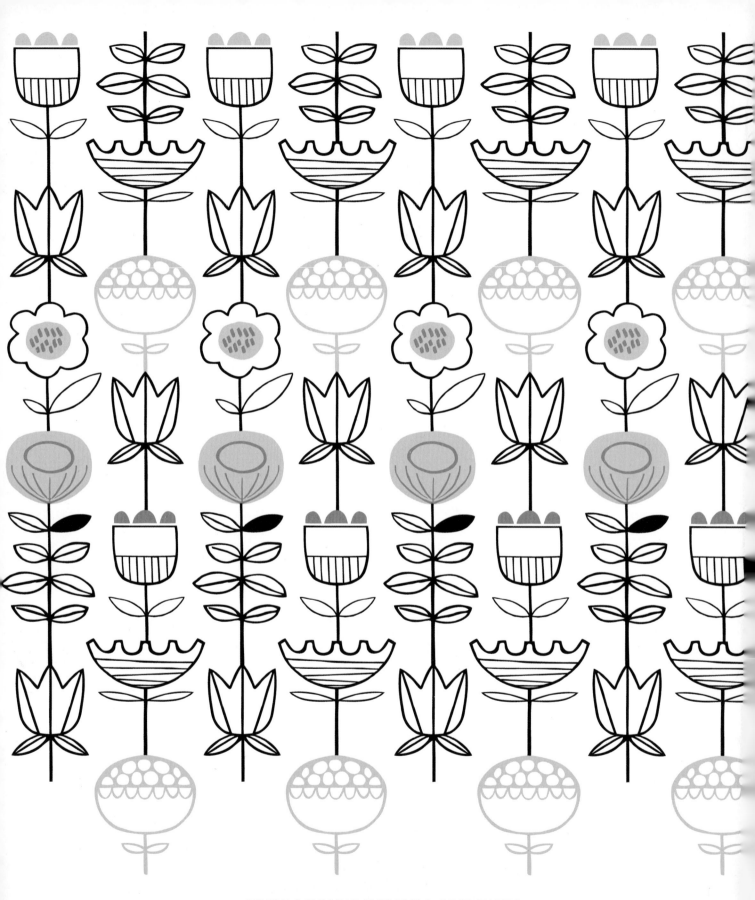

FINISH COLORING THIS FIELD OF FLOWERS.

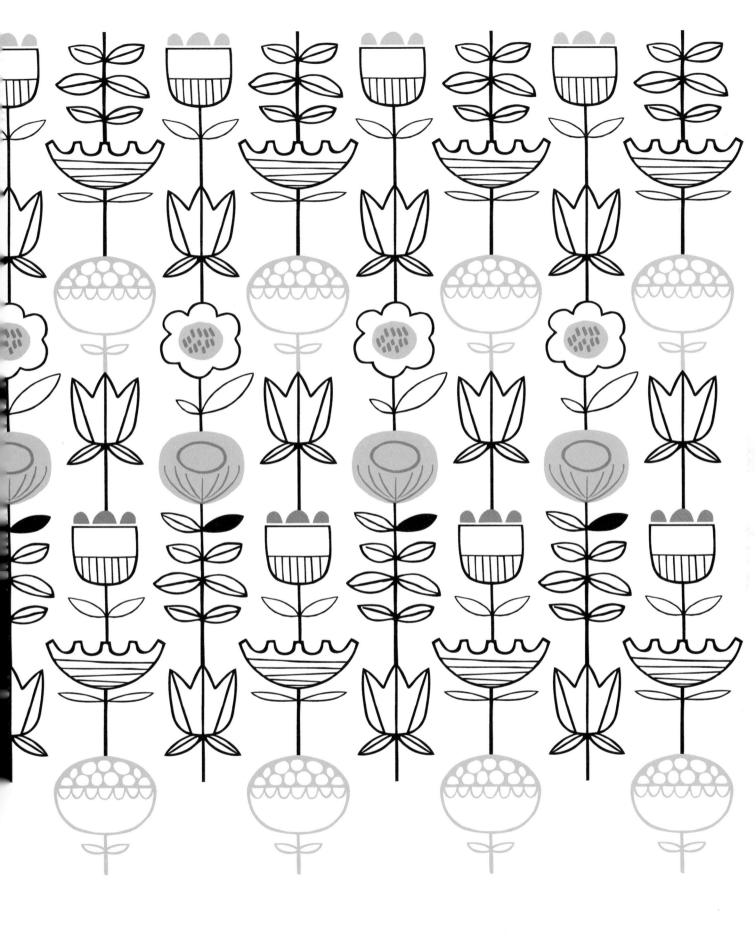

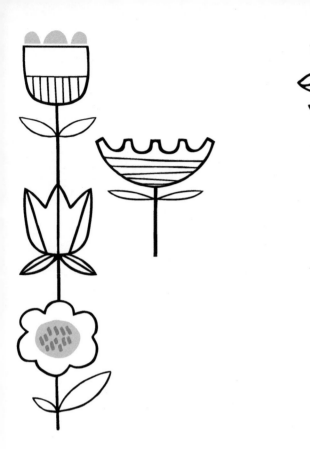

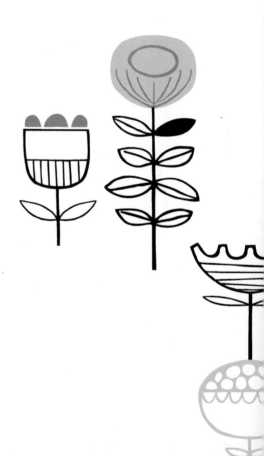

HELP THIS GARDEN GROW. DRAW AND DECORATE THE PATTERN WITH STICKERS.

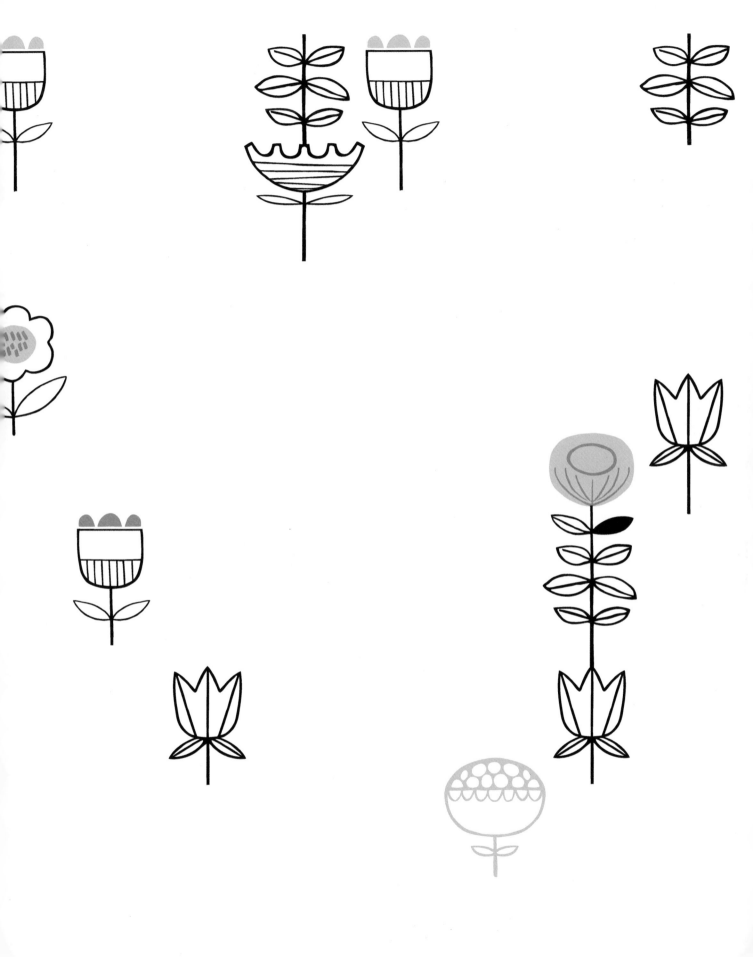

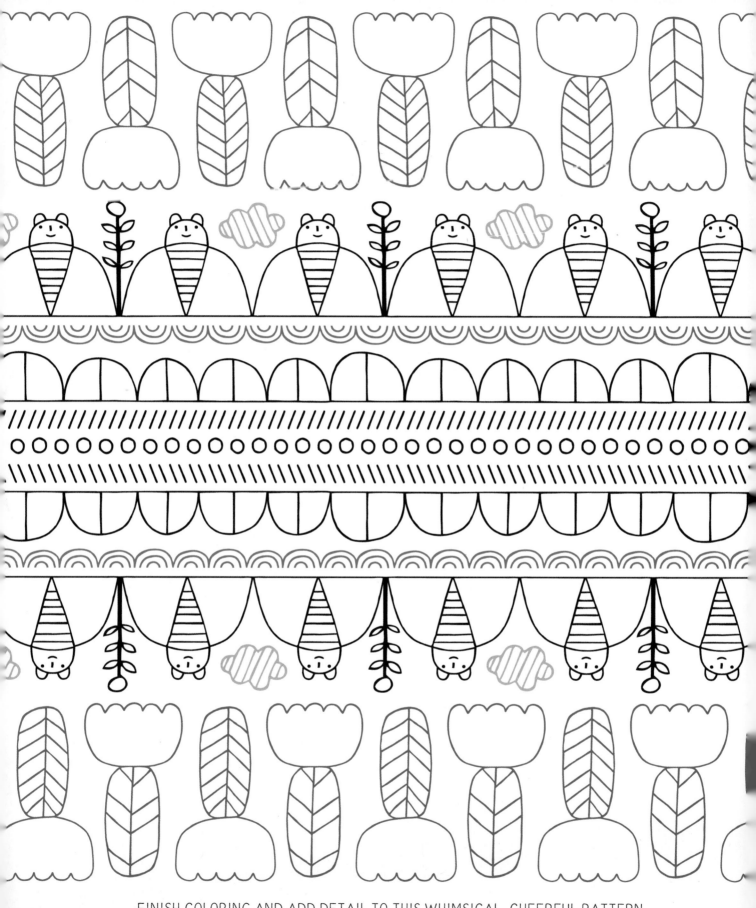

FINISH COLORING AND ADD DETAIL TO THIS WHIMSICAL, CHEERFUL PATTERN.

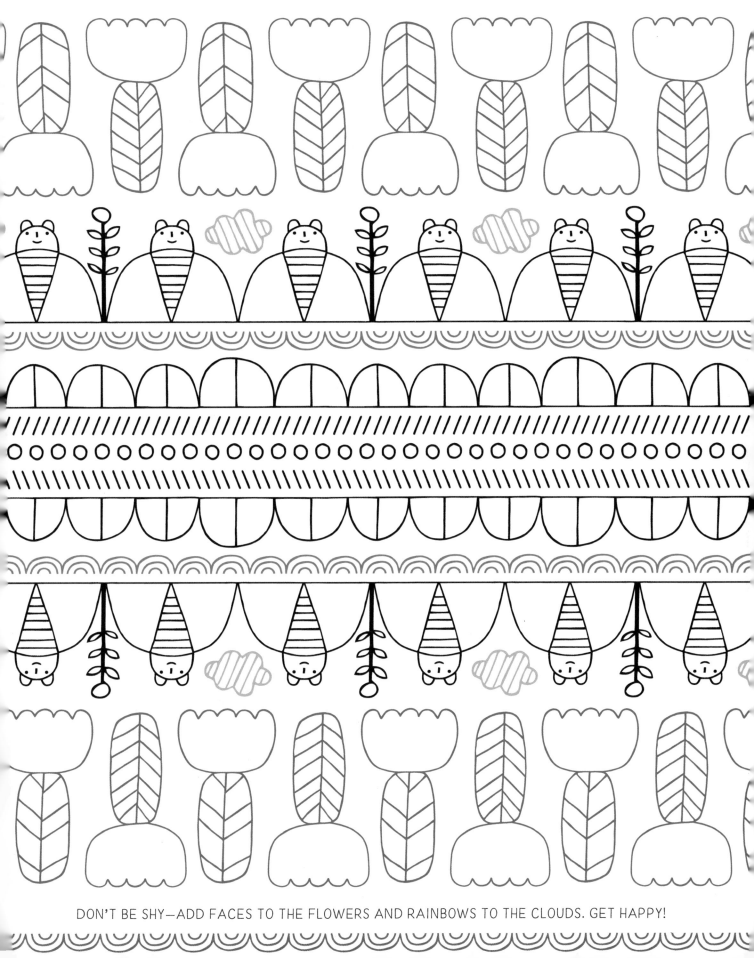

DON'T BE SHY—ADD FACES TO THE FLOWERS AND RAINBOWS TO THE CLOUDS. GET HAPPY!

DRAW ICONS OR STROKES THAT MAKE YOU HAPPY. DECORATE THE PATTERN WITH STICKERS.

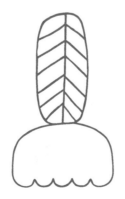
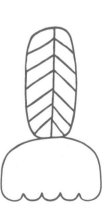

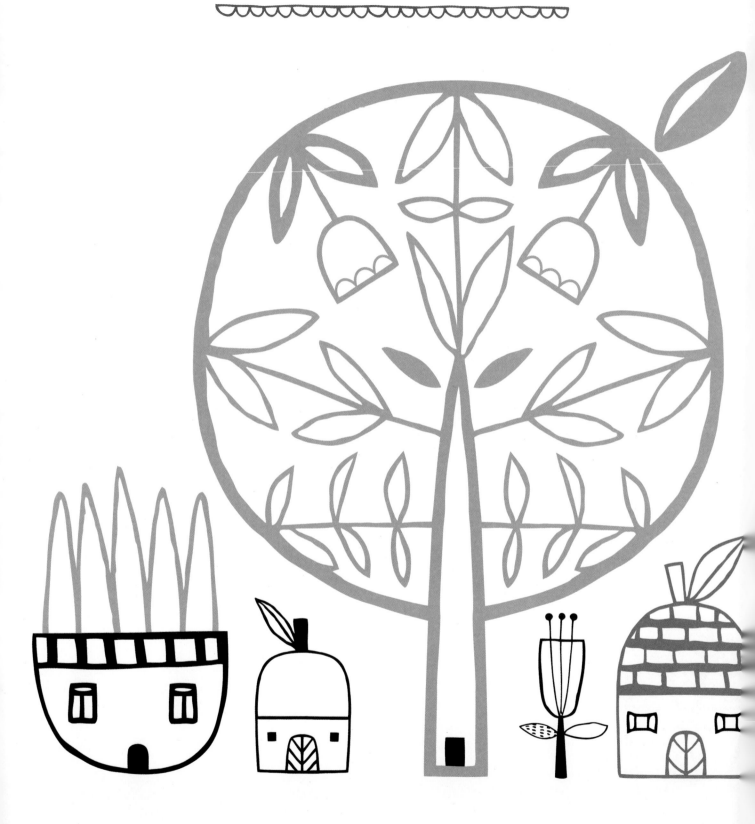

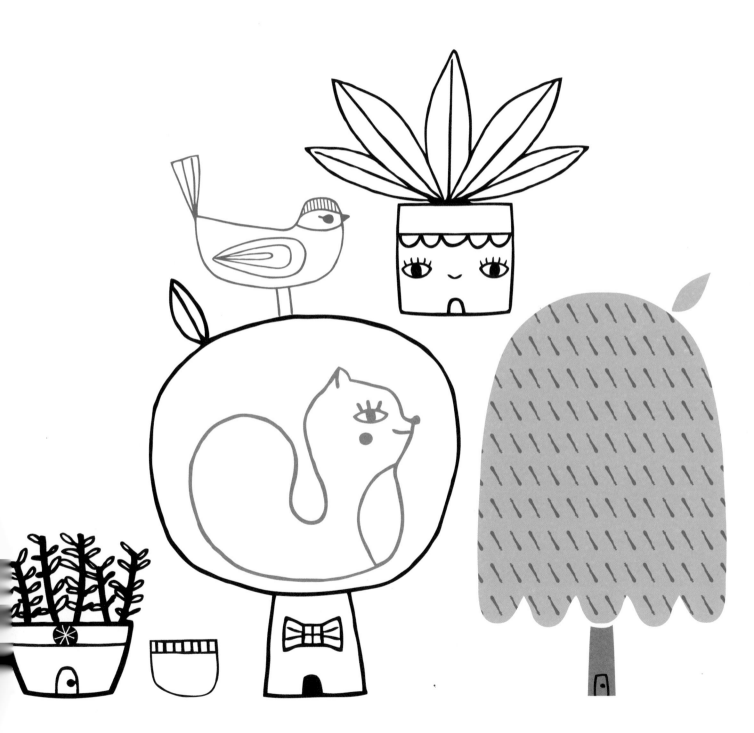

ADD MORE PLANTS AND GREENHOUSES.
FILL THE NEIGHBORHOOD WITH STICKERS.

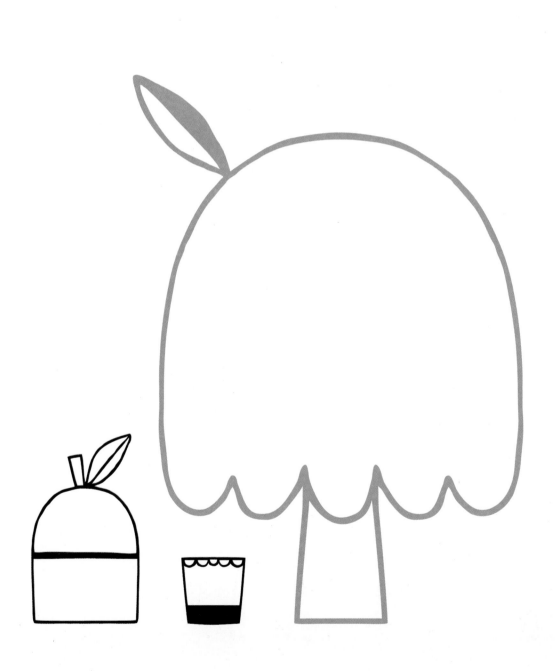

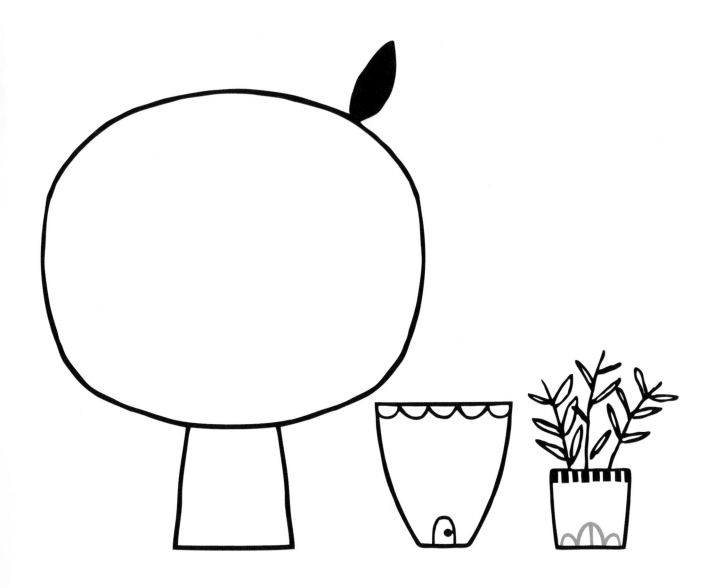

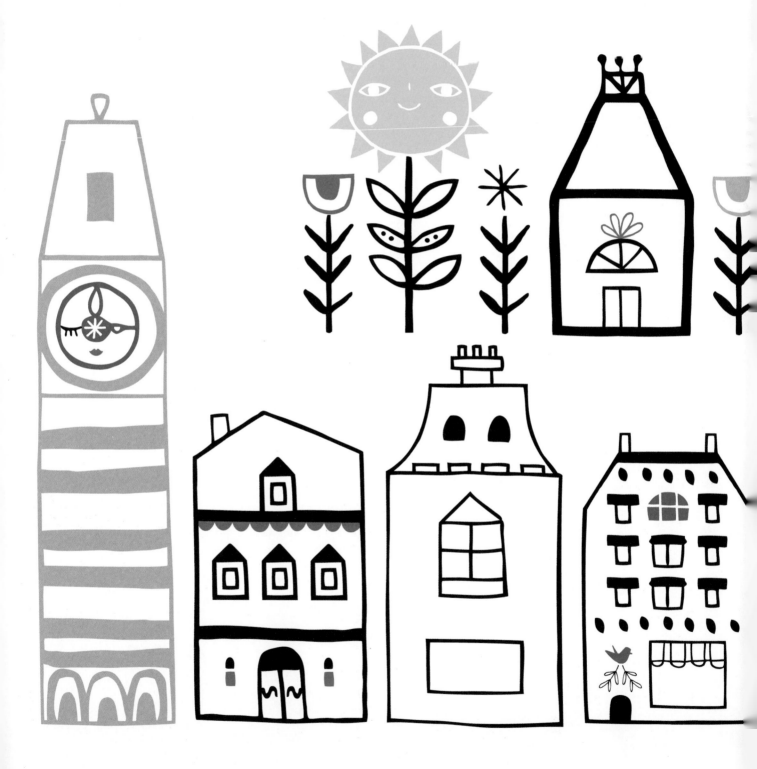

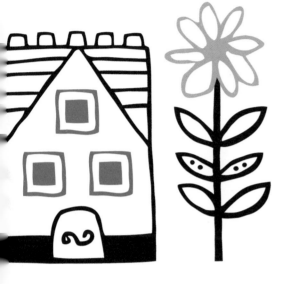

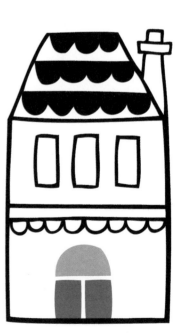

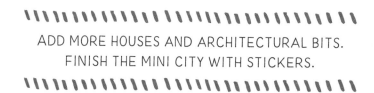

ADD MORE HOUSES AND ARCHITECTURAL BITS.
FINISH THE MINI CITY WITH STICKERS.

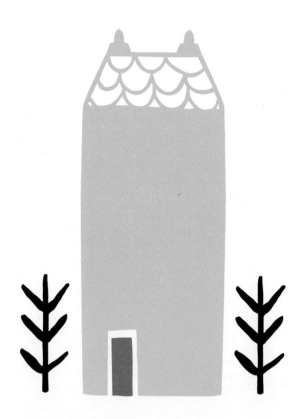

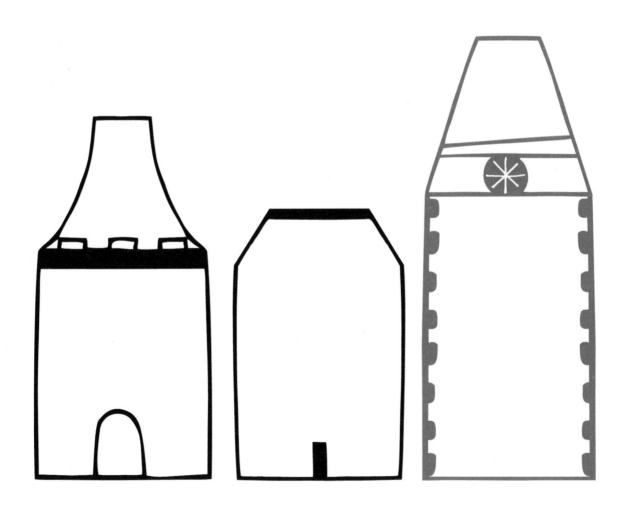

FINISH COLORING AND ADD FRUIT FLAVOR TO THIS FUNKY BUNCH.

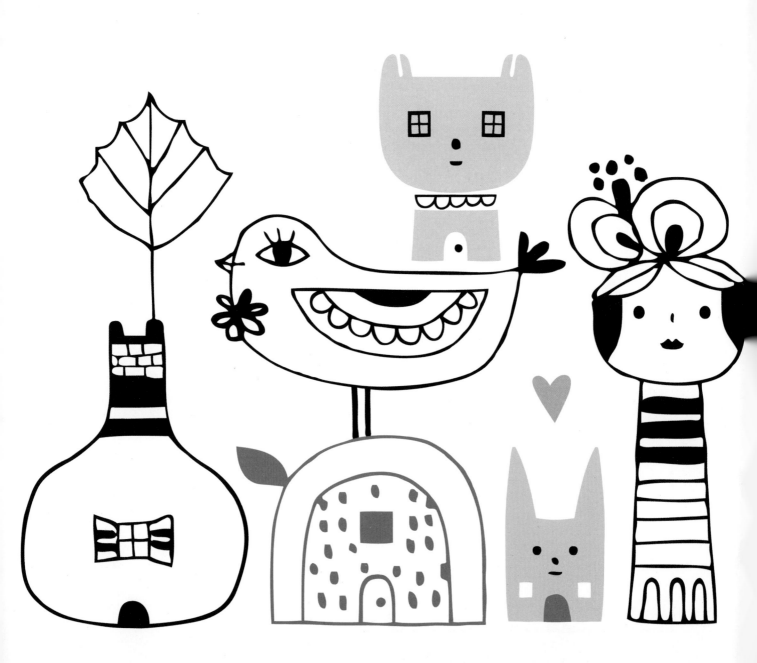

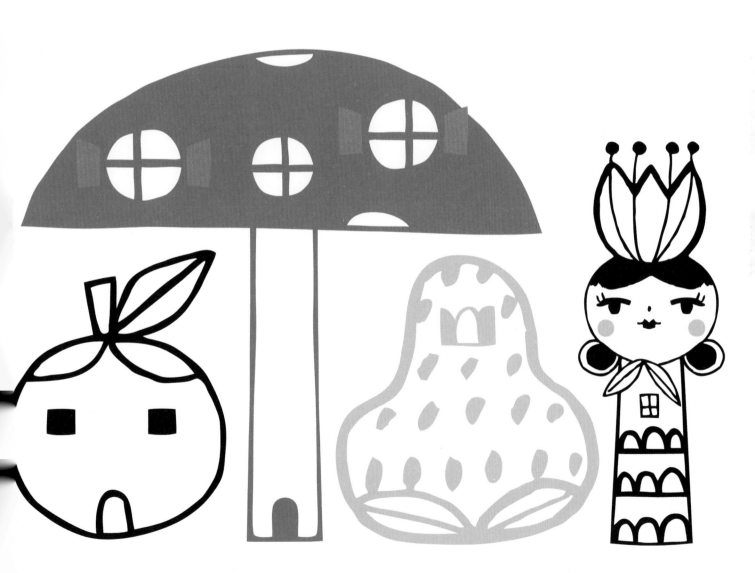

ADD UNUSUAL HOUSES AND SWEET NEIGHBORS.
FINISH THE TOWN WITH STICKERS.

ABOUT THE iLLUSTRATOR

SUZY ULTMAN WAS BORN IN PENNSYLVANIA AND HAS LIVED ON THREE CONTINENTS, ALWAYS TAKING IN THE CULTURE AND COMMUNITIES, ALLOWING THEM TO INFLUENCE HER VISUAL AESTHETIC. AS A CHILD, SUZY SPENT TIME COLLECTING STICKERS, PLAYING BOARD GAMES, PICKING BERRIES IN THE WOODS, PERFECTING HER SNOOPY SKETCHES, ADVENTURING WITH HER SISTERS, WOODWORKING WITH HER DAD, AND BAKING WITH HER MOM. SHE EMBRACES BEING IN BEAUTIFUL HABITATS SURROUNDED BY NATURE'S PALETTE OF COLORS, TEXTURES, AND FORMS. SUZY EXPLORES THE WORLDS WITHIN OUR WORLDS, THE LITTLE DETAILS THAT MAKE US SMILE, AND THE CONNECTIONS THAT MAKE US ALL PART OF THE GLOBAL COMMUNITY. SHE IS NOW ENJOYING A NEW ADVENTURE, LIVING IN THE LOVELY MIDWEST, WHERE SHE SCOUTS FOR CARDINALS AND ENJOYS CHOCOLATE-CAYENNE ICE CREAM AT THE LOCAL SCOOP SHOP.

VISIT HER WEBSITE AT WWW.SUZYULTMAN.COM, ON INSTAGRAM @SUZYULTMAN, OR ON TWITTER @SUZYULTMAN.

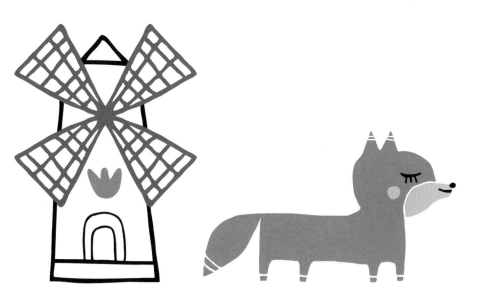

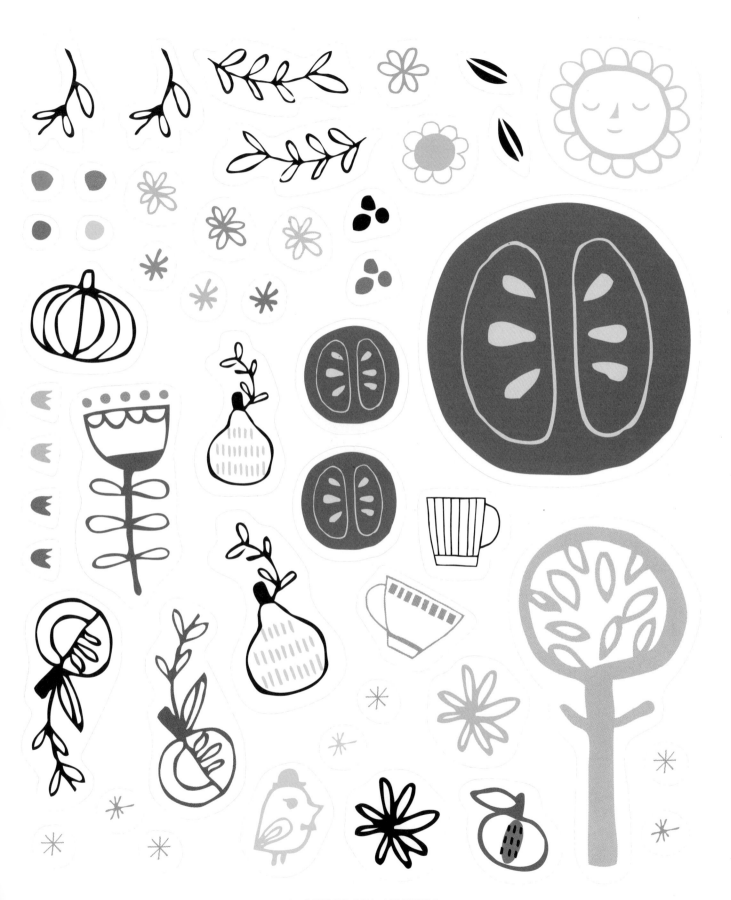

CAREFREE GIRL STICKERS

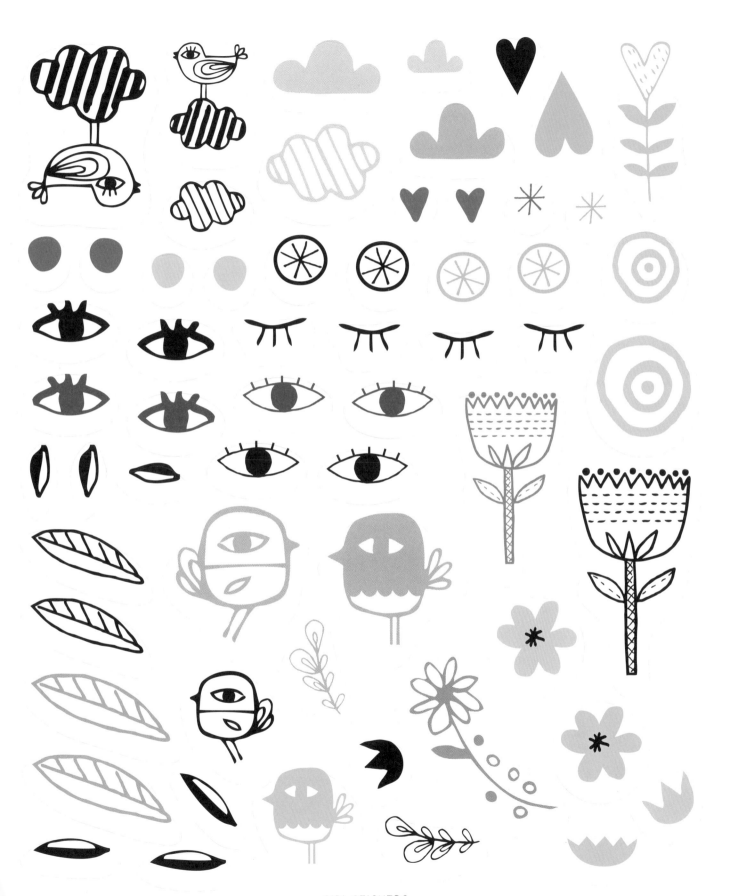

GIRL STICKERS

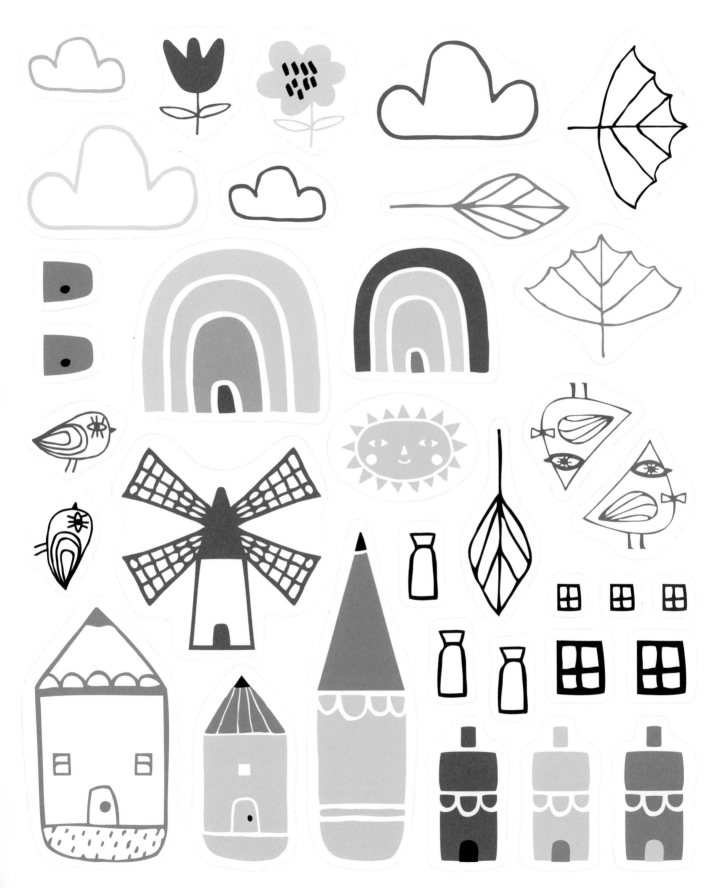

ARTSY TOWN STICKERS

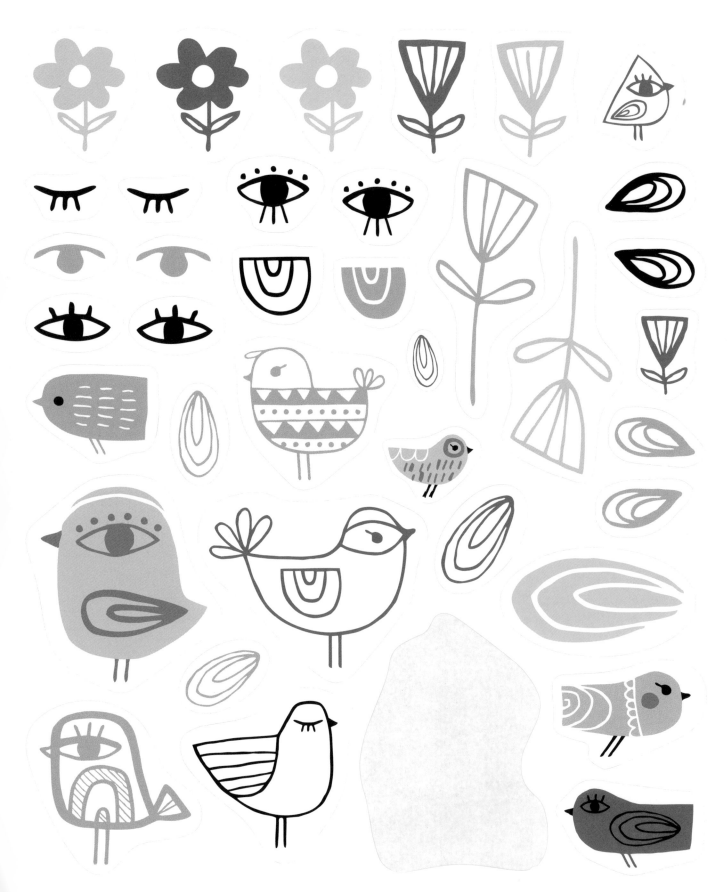

BIRD STICKERS

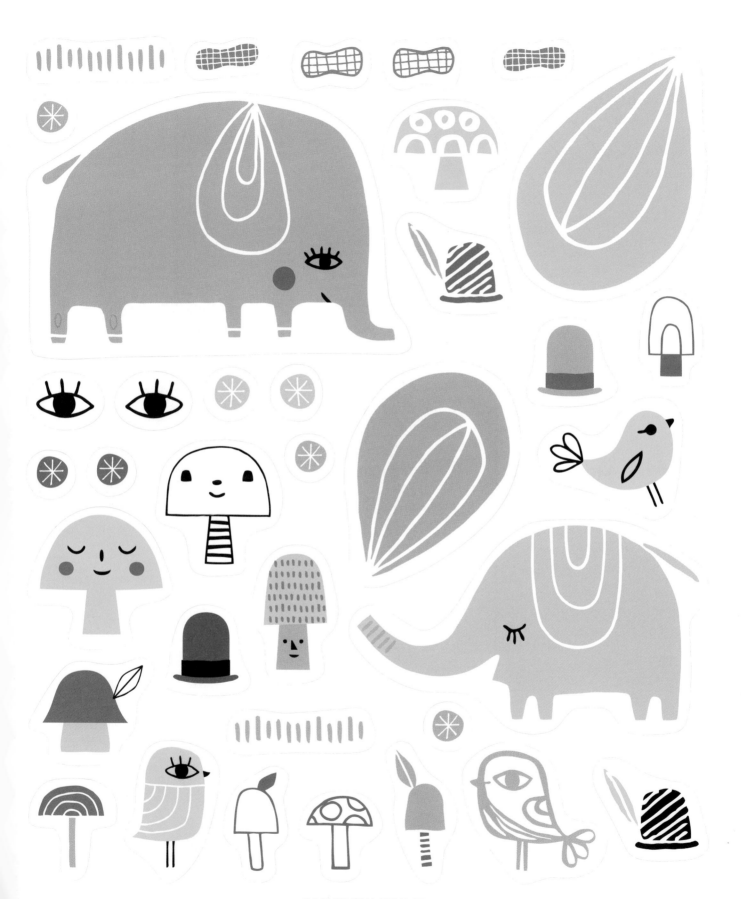

PACHYDERM STICKERS

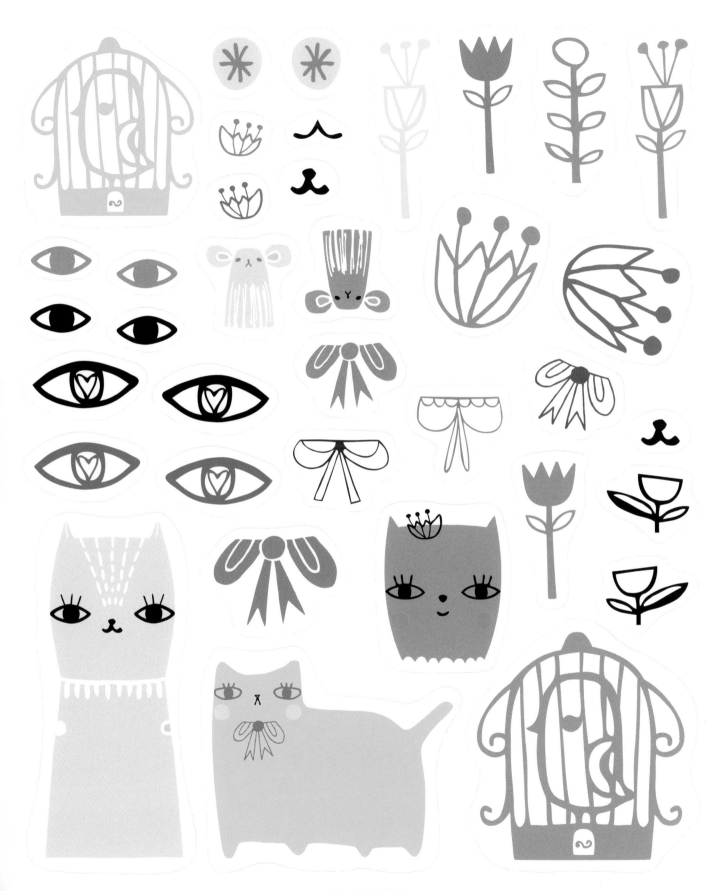

CAT STICKERS

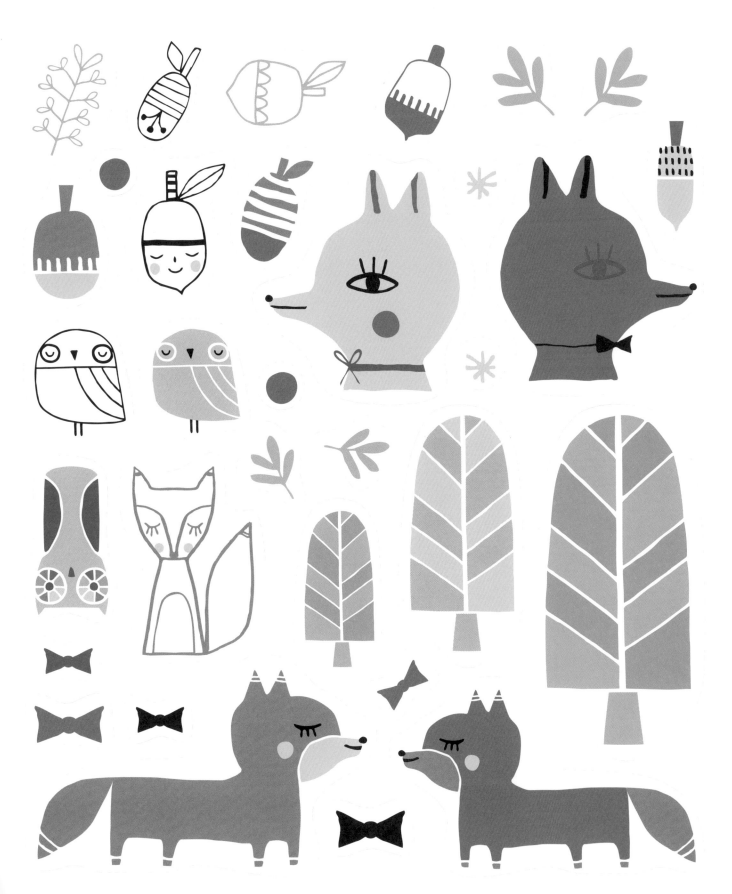

FOXY STICKERS

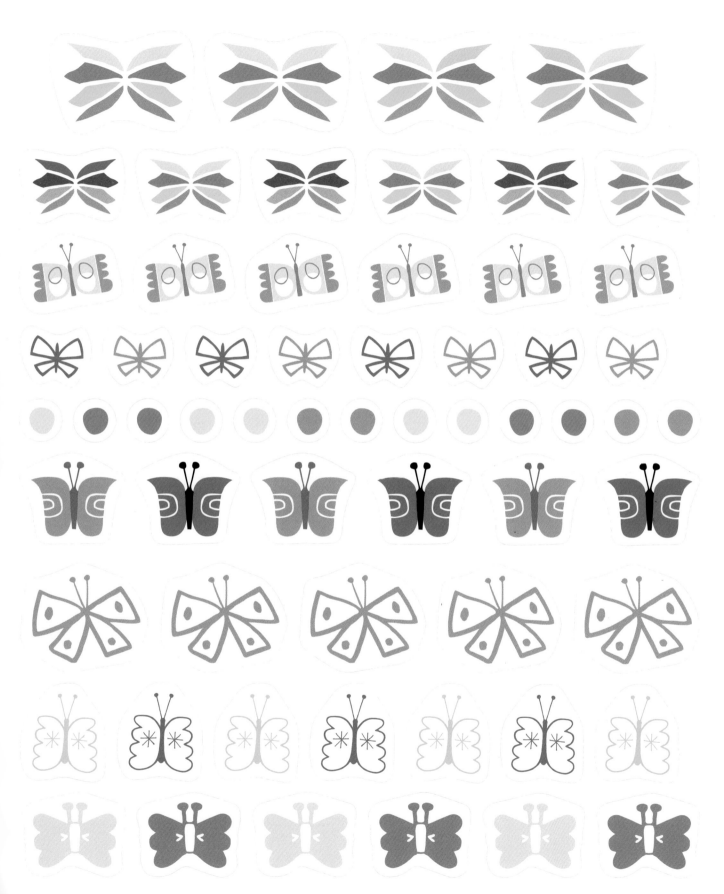

BUTTERFLY STICKERS

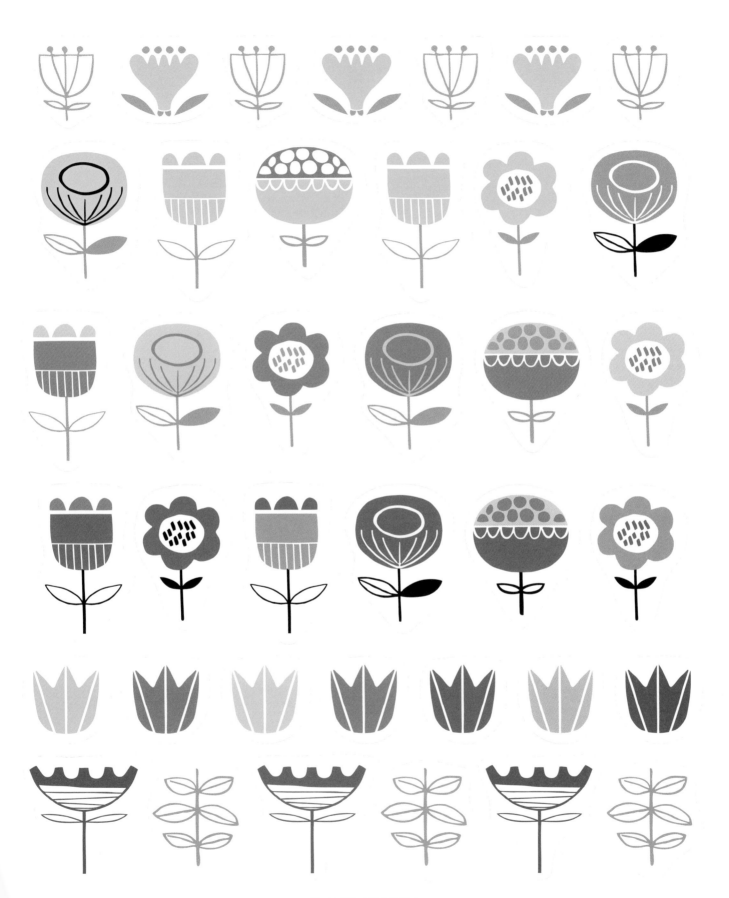

FLOWER STICKERS

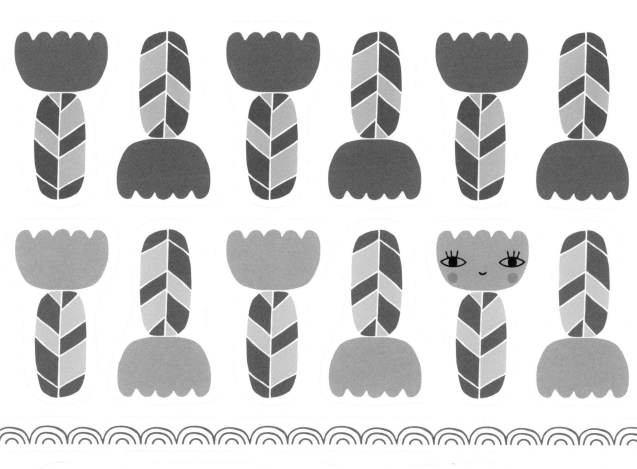

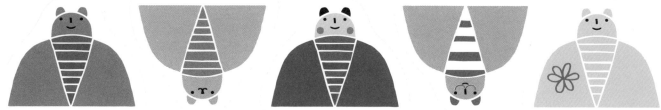

HAPPY DAY STICKERS

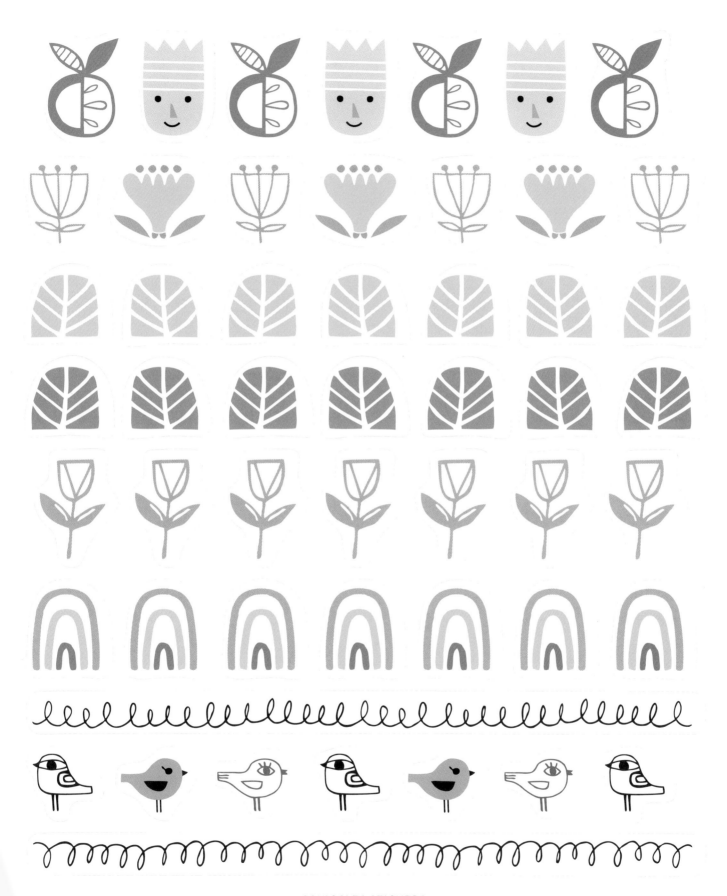

SQUIGGLES STICKERS

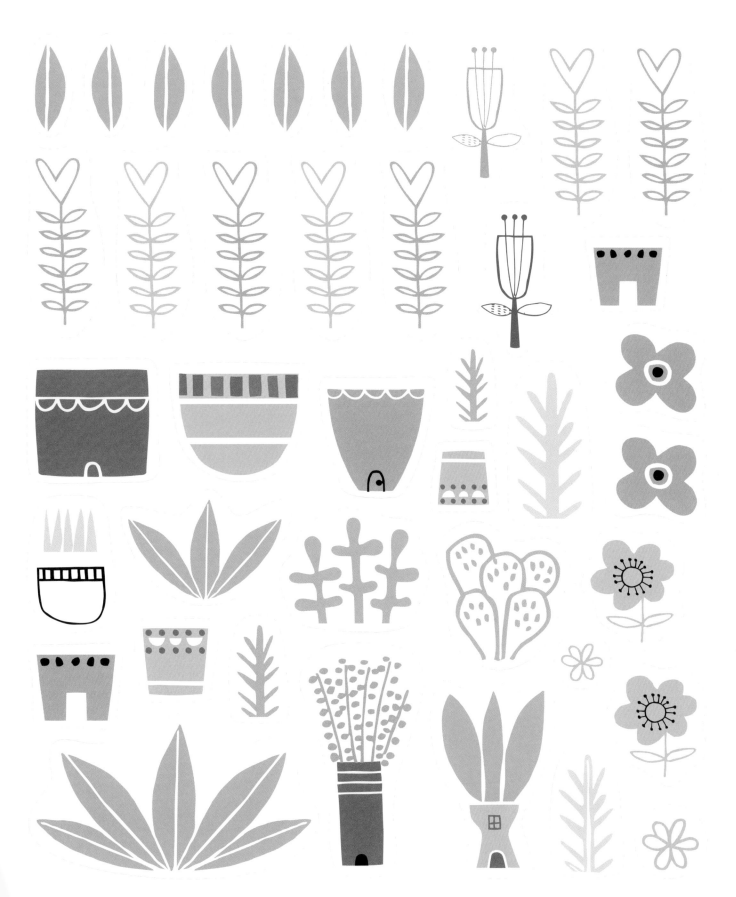

PLANTVILLE STICKERS

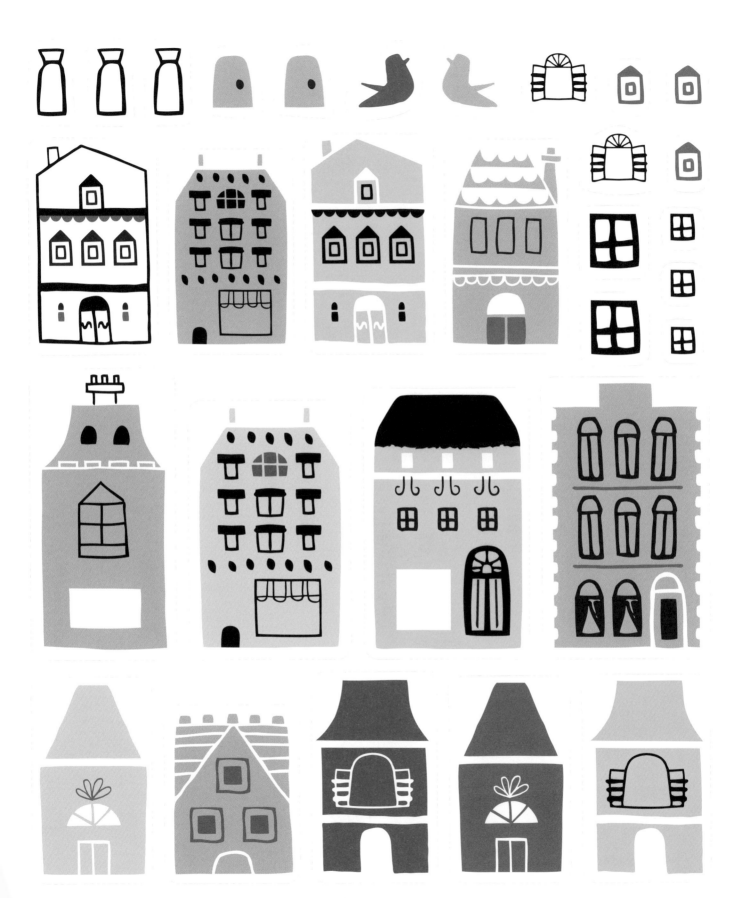

QUAINT TOWN STICKERS

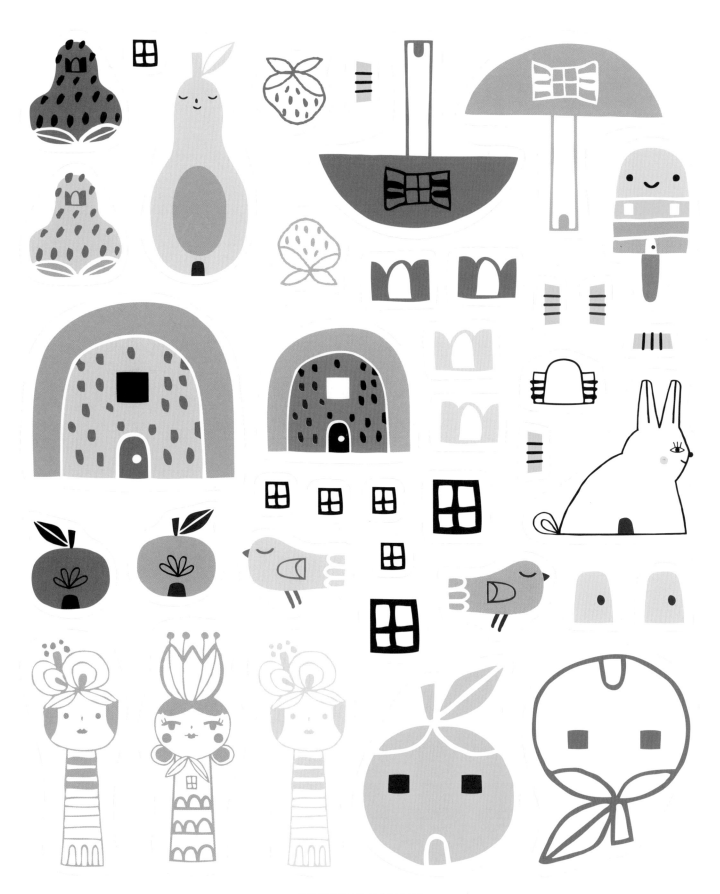

FRUITVILLE STICKERS

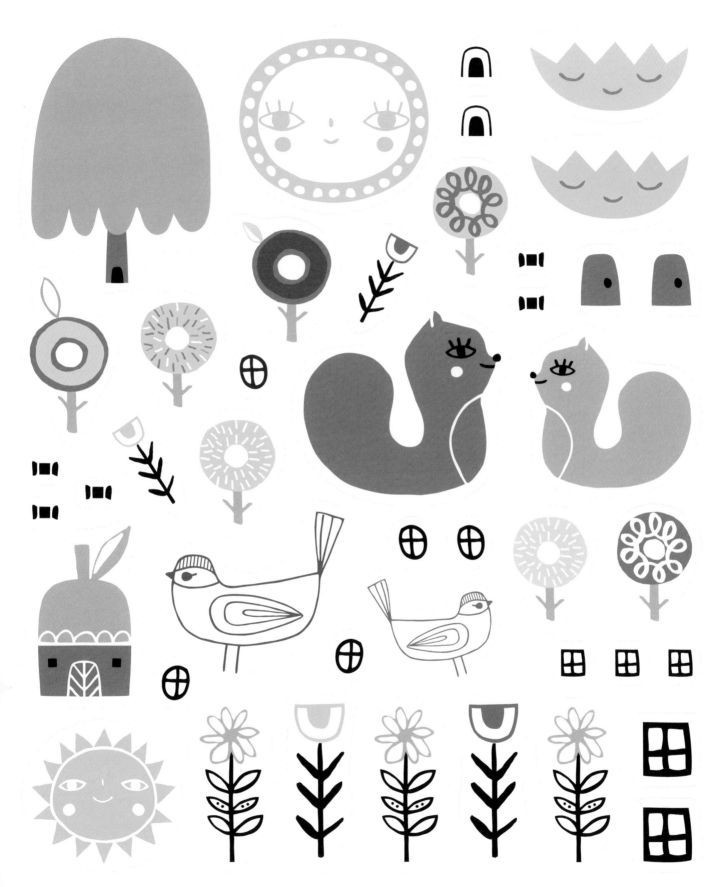

EXTRA STICKERS

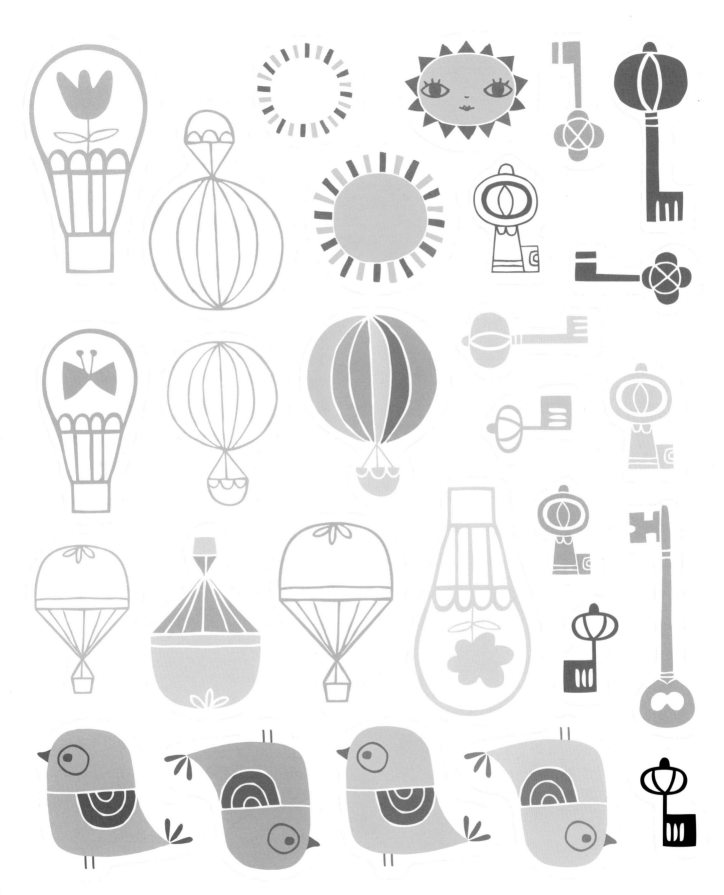